Table of Contents

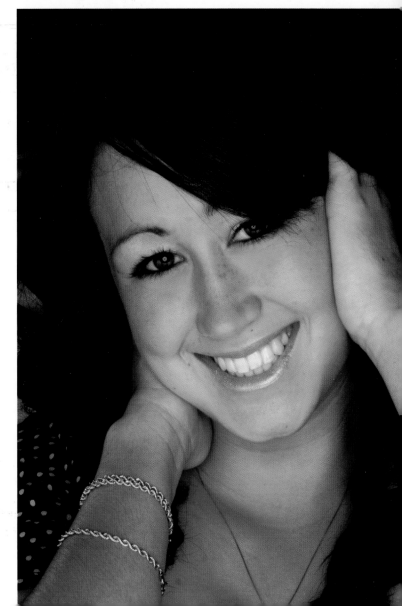

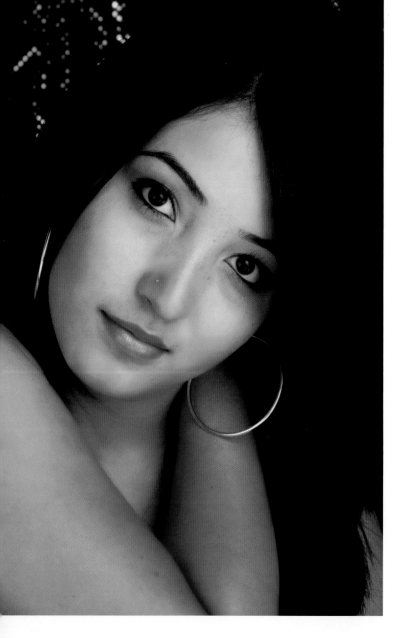

Introduction

Why Head and Shoulders Portraits Sell

This is the tenth book I have written, and I think it is one of the most important for the majority of photographers. Almost 70 percent of the sales in my studio (and this is the case with many others photographers I have talked to) are generated from head and shoulders portraits. Yet, while this one type of portrait often makes up the bulk of the income for a studio, many photographers look at head and shoulders portraits as the portraits that "have to be done" for the mothers, grandmothers, yearbooks, and business cards—the portraits they have to get out of the way so they can get to the more exciting full-length poses.

In the senior-portrait market, the full-length pose is often looked at as the way to set your self apart from the contracted studio that typically doesn't offer this type of image. Yet, while we offer everything to every client, the most requested portraits are the close-up shots that we will be discussing shortly, not the full-length poses. And as the average size of our clients seems to keep getting larger, I can't imagine this is a trend that is going to change. A tight close-up of the face can be a lot easier on the ego than a full-length image.

Keep in mind, I look at a head and shoulders image as an image with a larger facial size that is cropped somewhere above the waistline (at least in most cases). You will find that, in dealing with your clients, the facial size is much more important in most images than exactly where the portrait is cropped. As you'll see, I often pose a subject for a full or three-quarter length pose that can also be composed as a beautiful close-up. Looser framing for a yearbook or business portrait (slightly above the waist) also gives me cropping options that framing at the top of the shoulders does not.

In the upcoming chapters, we are going to look at each aspect of designing a head and shoulders portrait that not only looks beautiful but pleases your clients. That is the key to success in photography—whatever kind of portrait you specialize in creating.

> The most requested portraits are the close-up shots, not the full-length poses.

1. Creating Portraits by Design

It's About Them, Not You

To design an effective, salable portrait you must understand many factors and make many decisions. The first and most important consideration is one that many young photographers completely overlook—and it's why so many of them never make it to be an old photographer like me. The most important consideration in designing a portrait is the person you are designing the portrait for.

Success in portrait photography is about delivering what your clients want.

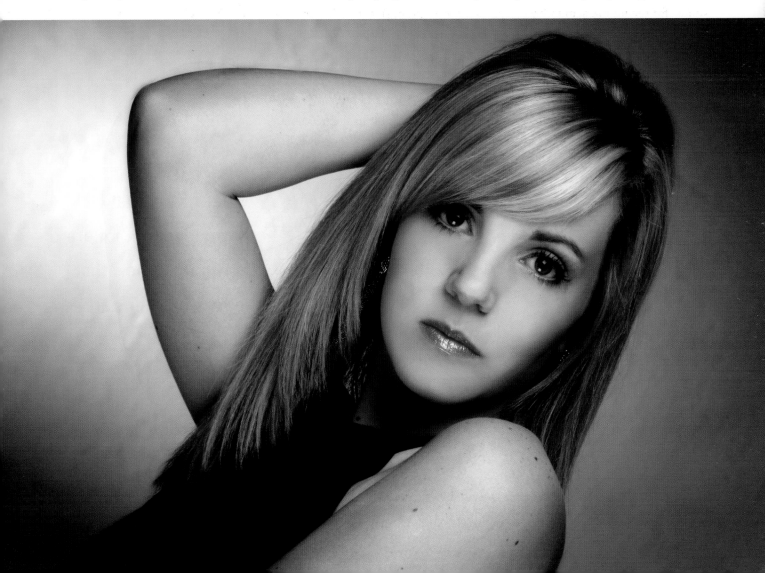

If you don't understand precisely what their expectations of the portrait are, you'll never be able to meet those expectations.

Judging by the e-mails I receive, this approach—my philosophy of putting business decisions (like pleasing the client) above the personal artistic choices that I might otherwise make—causes concern among some younger photographers and photography teachers. Many of these younger photographers remind me of when my high-school-age son commented that he was going to own his own business because he didn't want a boss telling him what to do all the time. I explained to him that, to be a successful businessperson and own a company, you don't just have *one* person telling you what to do, you have *every* person walking through your door telling you what to do. If you are going to keep your business running, you had better listen and make it your highest priority to give each client what they truly want.

It's not about us, it's about them. If you have a hard time with that concept, I can guarantee that you will find it nearly impossible to be successful in this profession. The ideas I present here are taken from a successful working studio that has been in business for over twenty-three years. That said, all any photographer (myself included) really knows is what is working for his or her clients in the area they work in. So I encourage you to test these ideas; use the ideas that work and throw out those that don't.

Meeting Your Clients' Needs and Desires

What does the client expect and why is he or she having the portrait done? When someone hires you to take a portrait there is a need, and that need has created a desire. Without a need and a desire, a person will not call your studio. Once they do call, if you cannot meet that need and fulfill the client's desires, you will not be a successful professional photographer. While some photographers take the time to talk with a client and understand what they desire and what need the portrait will be fulfilling, many simply meet the client in the camera room and go through that photographer's favorite ten poses. If that doesn't make the client happy, it must mean that they were a difficult client! What has actually happened, however, is a failure of communication that leaves neither party happy; the client doesn't like their images and the photographer doesn't like their sales figures.

Let's look into the day of a photographer who doesn't concern himself with the needs and desires of his clients. The doors of the studio open and the first session is an attractive woman in her thirties. She says she is there for a head shot and has a variety of clothing for the photographer to look at. He figures that a woman this age who comes in for a head shot with a variety of blazers, probably needs a business portrait. The client doesn't seem thrilled with the shoot, but the photographer assumes she is just a reserved person. Thirty minutes later he is done and the woman is on her way to the viewing room.

What has actually happened is a failure of communication that leaves neither party happy.

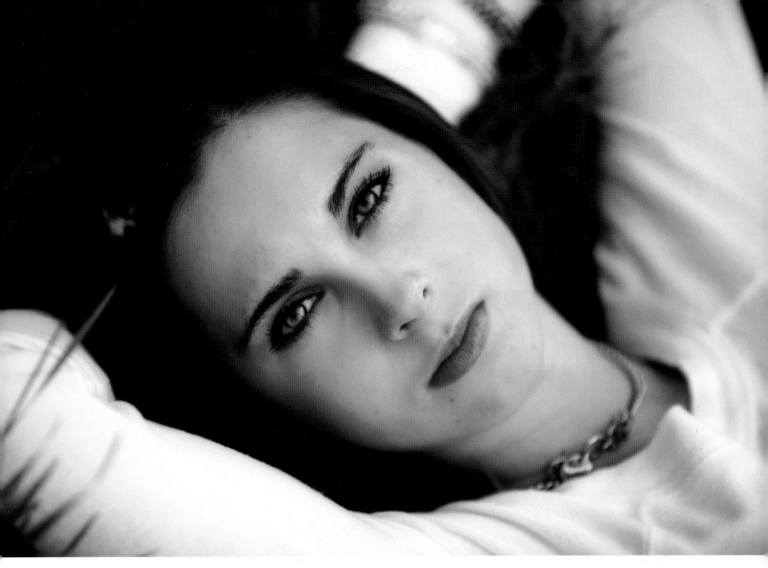

If you want to please your clients—and make a living in this busines—you have to start with the end in mind.

The next session is ushered into the camera room. She's a stunning twenty-two-year-old girl. She tells the photographer that she wants a photo from the waist up and she also has a variety of clothing. The photographer notices that most of her outfits consist of low cut tops and short skirts. Noting that she is a shapely woman, he assumes that she is doing photographs for a love interest and selects the clothing accordingly. Since she is just "so cute" (and so much of her was showing), he decides to take some extra photos for his sample books. He runs over the session's scheduled time but feels it was worth it, because now he can put new samples in his books and maybe a new sample on the wall.

The third woman is a little unhappy because she is starting her session 35 minutes late. She's a refined-looking woman in her fifties. She looks very successful and the only thing she says is that she wants nothing that shows below the waist and nothing too close-up to show her wrinkles. This woman also has clothing, but it is all very trendy for a woman her age and quite casual. This one has the photographer really confused, but he thinks that he will go through his most popular poses and she will like something.

In each of these scenarios, the photographer made logical assumptions given the limited information he had to draw on. Unfortunately, the client in session

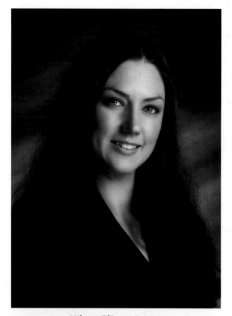

What Client 1 got.

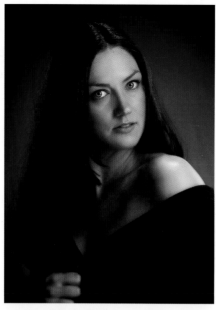

What Client 1 wanted.

LEFT AND FACING PAGE—*In this series of images, we filled the need and the desire of each of our fictional clients in the above scenarios (although this young lady is of a different age than those in the examples).*

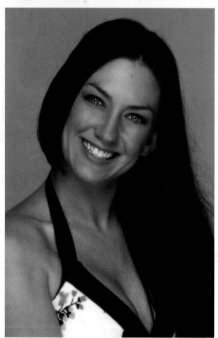

What Client 2 got.

What Client 2 wanted.

number one actually wanted an alluring portrait for her husband (that was her need) and was slightly embarrassed about telling the male photographer her ideas. Since she wears suits each day in her business, she thought her husband would find it sexy if she acted as though she was removing the blazer to show her bare shoulders (that was her desire). She isn't as thin as she used to be and felt that showing as little of her as possible would be the most flattering. The photographer didn't meet her desire, so no sale resulted from session one.

In session two, the young lady had just received her real-estate license and wanted a portrait for her business cards. She had no professional clothing, so she

The photographer didn't meet her desire, so no sale resulted from session one.

brought what she had. Although there are no portraits that would be usable for a business card, she did like some of the images the photographer did—after all, he pulled out all the stops for her session. She decides to get an 8x10 to give to her boyfriend. It's not a big sale, but at least it is something (and when you're a photographer who puts your own desires above your client's, you have to be happy with what you get).

The photographer is counting on the third session to save the morning—and to let him pay the rent on time. The client clearly has money and he wants some of it. As it turns out, the client actually wanted a soft, fun portrait (the desire) to give to her mother, who recently went into a nursing-home (the need). While this woman had the most available money to spend of all the clients that morning, she is also accustomed to getting exactly what she wants for her money.

This woman had the most available money to spend . . .

What Client 3 got (above).
What Client 3 wanted (right).

While the images the photographer produced were of a professional quality, they didn't fulfill her need or desire. Once again, no sale.

Business and Communication

While this photographer may have learned all about photography, he never learned about business, or people, or communication. So what does he do? He goes to the next convention or seminar, sees me, and asks me why he is broke. He and many other photographers are going broke in this digital age because they don't understand that there are soccer moms out there who can create a beautiful portrait of a beautiful person. They don't need four years of college, just a wannabe model, a digital camera, and Photoshop—and they are almost as good a many graduated student photographers.

> You have to know how to determine what a client wants and produce those results.

The line between us and them is found in the ability to not only take pretty pictures but to give a client exactly what they want on demand. This isn't photography class where you can explore your own creative impulses, it's business—and you have to know how to determine what a client wants and produce those results. You begin with the end in mind.

Creating What the Client Desires

The first step in designing a portrait is finding out what the client wants. This

doesn't mean you have to have a personal consultation with each person you photograph, though. You can have a staff member talk with each client or have the client look through sample books to give you some direction for their session. However you decide to do it, you have to know what the client wants to be able to create it.

Once you find out what the client expects, then you need to start selecting everything that will be inside the frame of the image. These elements will all work together to achieve the final portrait. Listen to the client's use of adjectives as she explains what she wants. The use of words such as "soft," "dreamy," and "fun" leads me toward the use white and pastels for the clothing, background, and set selections. If a client mentions the words "alluring" or "sexy," I look more toward darker tones and stronger primary colors. While this is only a starting place, it is the first step in designing your client's portraits.

As you talk to your client, you can begin to refine your ideas about the image. Begin with the

clothing. For example, while talking with a client about her "sexy portrait," she may comment that she doesn't want to look sleazy. In that case, I would select more alluring (not overtly sexy) clothing in softer colors for a more gentle appeal. Once the clothing is selected, the backgrounds can be chosen to coordinate with it (we will be discussing backgrounds in greater detail shortly).

Only when all these decisions are made am I ready to take my first test image. As the image downloads onto the computer, I quickly check for any issues I haven't yet fixed, as well for coloration and exposure. At this point, I am ready to pose the face to achieve the best angle and lighting (especially on the eyes) and then concentrate on the subject's expression.

Meeting Client Desires Means Making Money

The fact that I take the time to understand what my client actually wants—and know how to set aside my own tastes to give them what they desire—is why I'm making a great deal of money in this profession while other photographers are being run out of business by soccer moms. Professional photographers use the "ready, aim, fire" method of achieving excellent results. Younger photographers and soccer moms use the "aim, fire, see what happens" method. As a result, they don't know what to expect until the previews come back and the client is complaining about not getting what they wanted!

BELOW AND FACING PAGE—*The first step in designing a portrait is finding out what the client wants.*

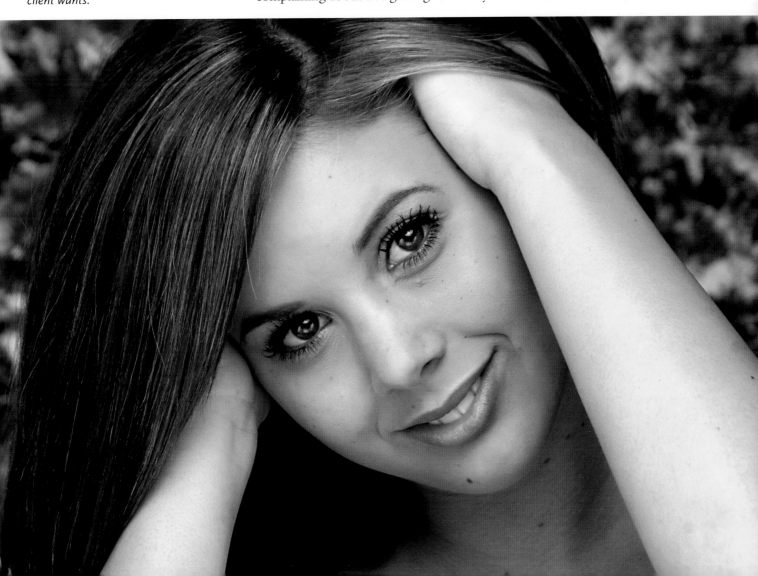

2. Tools of the Trade

I am not a photographer who advocates buying a certain brand of equipment. I don't take favors from any company in exchange for suggesting you buy or use their product. Being a frugal person, I prefer to purchase equipment that offers the best value I can find. Value isn't just buying the cheapest thing out

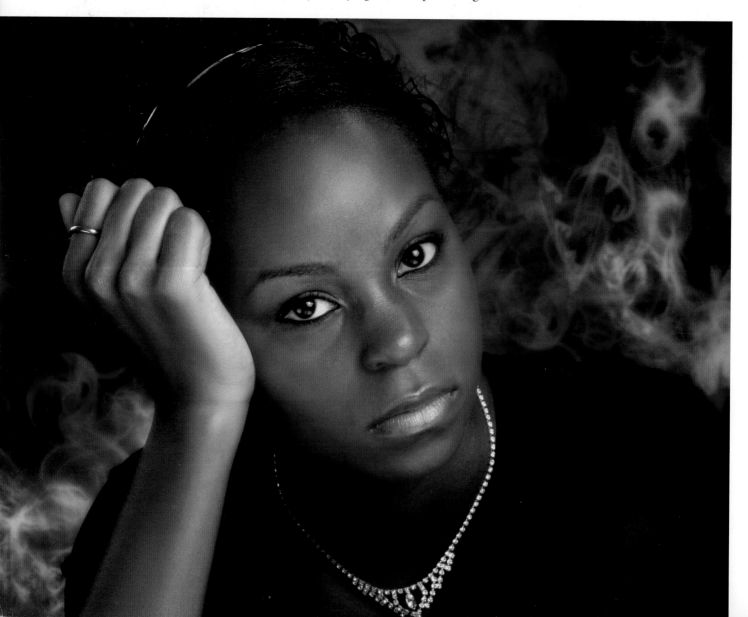

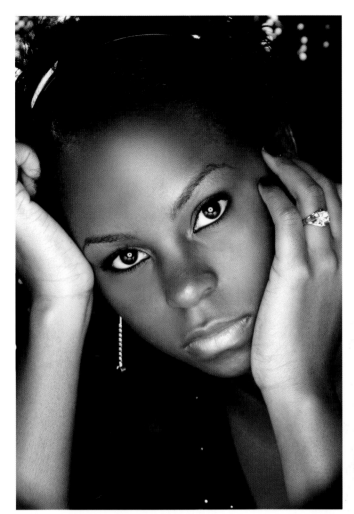
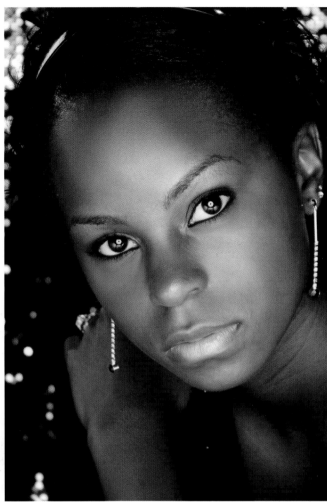

ABOVE AND FACING PAGE—*Creating great portraits isn't about owning the right equipment, it's about knowing (and using) the right techniques.*

there—especially when the economy brand dies right after the warranty expires. However, I also feel that if you buy the top-of-the-line cameras, lighting, and other equipment, you aren't as good of a businessperson as you could be. If you are the kind of photographer who has a camera that works just fine but still feels compelled to buy the newest digital camera when it comes out, you are buying *toys* not *tools*! We aren't children, we are businesspeople.

When I hire a new photographer or assistant, the first questions they ask are usually about equipment. I always reply with the same question: "Do you think that when two surgeons get together, they ask each other what brand of scalpel each uses?" Surgeons discuss techniques, not tools, because they are confident in their skill. Photographers tend to talk about tools, not techniques, because many people in our profession are not as confident in their skills as they could be. So as we discuss equipment, remember that it is the *skill* and not the *scalpel* that makes the difference.

Think Creatively

I have had student photographers e-mail me and exclaim, "You're successful— you can afford all this stuff. I'm poor and just starting out!" My response?

You're in a creative profession, so think creatively! I was young and poor once, too, but I didn't let the fact that I didn't have the money to buy certain equipment stop me from building or creating what I needed. Today, I may buy a certain reflector, but that's because in the hour I'd spend building one I can generate a lot of money for my company. Long ago, however, the time I spent building sets and painting backgrounds saved me more money than I was making in photography, so building my own stuff made sense.

If I suggest a reflector that's not in your budget, cover a piece of foam-core board with mylar. If I explain that I use a certain light box and you don't have it, use a cheap umbrella with the same reflective interior material as the box I use. With a little practice—okay, a lot of practice—you will create beautiful images that your clients will buy.

Camera Selection

When photographing inside the studio, I use a digital camera tethered to a laptop computer. I do not select the digital camera I work with based on what the advertisements say or what speakers at a seminar tell me I need. I buy cameras based on the final output size I intend to produce. (*Note:* In the not-too-distance future, we are going to be to at a point where the images from the latest, greatest digital cameras will actually record *too much* information. As we did in the days of medium-format fine-grain film, we will have to start diffusing images with larger facial sizes—just to give clients a preview that isn't scary!)

When I am in the market for a camera, I borrow or rent the cameras I am interested in and take some test shots. Then, I test the files to see how much they can be enlarged before they start to fall apart. Not all 10-megapixel cameras produce the same image quality or enlargement possibility. In the tests I have done, I found that the Canon digital SLRs, with their CMOS chips, typically allow a greater enlargement possibility than the other brands with CCD chips of a similar size. Again, this is for the way I shoot—I don't want you to sell your brand new Nikon and buy a Canon because I prefer them. If the equipment you have does the job, stick with it until it no longer works or no longer does the job.

If the equipment you have does the job, stick with it.

Camera Settings

JPEG File Format in the Studio. In the studio, I shoot JPEGs, because we show the client his or her images right after the session is over. If you know how to control your lighting and color balance, there is no reason to shoot RAW files. In fact, if you're shooting with a 10+ megapixel camera, RAW files just waste time and storage space in most sessions that have a final output size under 20x24 inches.

Custom White Balance. To ensure consistent images and printable-quality JPEGs, however, you need to do two things. First, you need to use a custom

Check your cameras
to make sure that all
the settings dealing
with contrast and color
are the same.

white balance. In the studio this is easy: you simply set your white balance and make sure that your lighting is consistent in its color. This means your light sources are all the same brand and power with flash tubes of the same approximate age (as flash tubes age, the color of the light [their color temperature] changes). Using a custom white balance will keep the coloration of your images the same from one background to another and even from one camera area to another. This is vitally important when it comes to producing final images that don't require a huge amount of color correction to match up. Also, if you are using more than one camera, check your cameras to make sure that all the settings dealing with contrast and color are the same.

Consistent Exposures. The second critical element when shooting JPEGs is ensuring consistent exposures. While I have been doing this for years and can judge how far to position my lights from the subject to get consistent exposures, it wasn't always that way. When I first started out, I would either focus on the client and position my lights where I thought they should be (which produced images that were all over the place in the terms of exposure) or I would drive my client crazy by metering each light for each shot.

Then, I discovered that I could use a string to measure the distance between each light and the subject or background (for the background light) to make sure my lighting produced the exposure and quantity of light I was expecting. I simply tied one end of the string to each movable light stand and cut the string off at the distance I had metered for the client to be positioned. To take this idea one step further, I metered my lighting to give me a 3:1 lighting ratio when the

A string can provide the key to repeatable exposure by ensuring that your lights are placed at a consistent distance from each subject.

main-light was placed at a distance that was the full length of the string from the client. Then, I also marked with a red dot the spot on the main-light string that would give me a 4:1 lighting ratio for when I diffused my images. This was an effective way to get a consistent exposure without having to meter each light with each background change.

One last suggestion: if you use this string technique, do your measurements when you are waiting for the client to finish changing so you aren't holding strings up to a client's face—measuring to the middle of the posing stool will be just fine!

Occasions for Shooting RAW Files. I do shoot RAW files during outdoor sessions in areas where I have not shot before. This gives me additional latitude while I am getting familiar with the settings and existing light conditions of a new location. I also shoot RAW files when I am photographing families or groups with smaller facial sizes, or when I am printing out larger wall portraits and need maximum clarity.

Many photographers like RAW files for all studio shoots. It gives them the latitude we used to have with print film, which would produce a usable image even when it was way overexposed or slightly underexposed. Shooting JPEGs on a digital camera is more like shooting slide film; it offers very little room for error. But then, back in the days of slide film we didn't have custom white balance, a histogram of the image, and a digital display that showed you each image while highlighting any overexposed areas for you. With these tools, if you can't be consistent enough to shoot JPEGs in the studio, you are either lazy or you need to work on your basic shooting skills.

Lens Selection

The most important consideration for portraits with larger facial size, such as head and shoulders portraits, isn't the camera you use but the lens. While some photographers use a variety of lenses to achieve unique effects, the majority of head and shoulders poses are taken with a portrait lens. A portrait lens is considered a 100mm–135mm lens for 35mm-based cameras and 120mm–185mm lens for medium format–based cameras.

These numbers haven't changed with digital—*unless* the chip in your camera is smaller than a full frame of 35mm film. Should you use a camera with a smaller than full-frame chip, there are two important considerations. First of all, the smaller the chip is, the more it changes the magnification of the lens (check the focal-length factor for your camera to determine how your lenses will function). Second, chips that are smaller than a full 35mm film frame tend to produce images with a greater depth of field.

This is a problem for portrait photographers, since we often rely on reduced depth of field to help separate our subjects from the background. If you use a camera with a smaller chip, you will need to work with the lens opened up more

> The most important consideration isn't the camera you use but the lens.

To control background softness, I now buy lenses that have larger maximum aperture openings . . .

than you might have in the past. This will provide the narrower depth of field you want.

The biggest problem with the depth of field of these cameras tends to occur outdoors. Working with medium format film cameras, a telephoto lens, and a little diffusion, my outdoor scenes and backgrounds were beautiful. With digital cameras that have a smaller chip, I not only need to open up the lens more, I have to use much longer telephoto lenses to get the same effect. For most of my outdoor portraits taken with these cameras, I use a telephoto lens between 220mm and 400mm to give me controlled focus and soft backgrounds. The only downside to working with a long telephoto is the distance I must be from the client—but I look at going back and forth to fix hair or adjust a pose as good exercise.

As you can see, my lens selection has changed since I have been shooting digital. To control background softness, I now buy lenses that have larger maximum aperture openings to reduce the depth of field and give me pin-point critical focus. With film, I used to work with my aperture set at f/11, which softened the background while giving me a little extra focusing depth (since medium format film cameras weren't autofocus). With digital, I work with an aperture around f/5.6. This makes my backgrounds appear as they used to with film at f/11. If you're going to shoot at f/5.6, though, the maximum aperture of the lens should be at least f/2.8, since the best quality of a lens is achieved two stops from the minimum or maximum aperture. (*Note:* Despite this, I do shoot with my lens wide open sometimes; it achieves maximum softness for the background and provides a slight vignette.)

Camera Support

When I am shooting a head and shoulders pose, I always use either a camera stand (in the studio) or a large tripod (outdoors). The reason I have the camera supported instead of hand holding it has nothing to do with movement. The two factors that sell more photographs than anything else are the expression and the look of the eyes. For both of these factors, I want the subject looking at me—not at the lens of the camera.

The best expressions are possible when a subject is looking at you and "mirroring" the expression you want the subject to have. When a smile is wanted, just smile at the subject, say something funny with an upbeat tone in your voice and you will have a beautiful natural smile. To have the subject relax the smile, just relax your smile and talk with a more relaxed tone in your voice (we'll talk more about expression in chapter 6).

The eyes are the other important reason for using a camera support. When you look at some portraits, the eyes lack life. This can be because the portrait was improperly lit or it can be because the subject was not looking into the eyes of another person. There is a certain spark in the eyes when the subject makes

A ball head on your tripod makes it quick and easy to adjust your camera position.

eye contact with another person; this is lacking when a subject looks at the camera or some point in the camera room. Even in profiles, I will place a person where I want the subject to look.

On each camera support, I use the Manfrotto 322RC2 ball head with large grip. I love this head, because it makes adjusting the camera so fast and easy—and if you tilt your camera frequently, it's a must!

So many times, a lifeless portrait can be brought to life with just a tilt of the camera. In the first photo, the vertical and horizontal lines in the background look too structured. In the second photo, the tilt of the camera adds an interesting look to an otherwise ordinary portrait.

When the subject has long, full hair, a fan can add flair to the image.

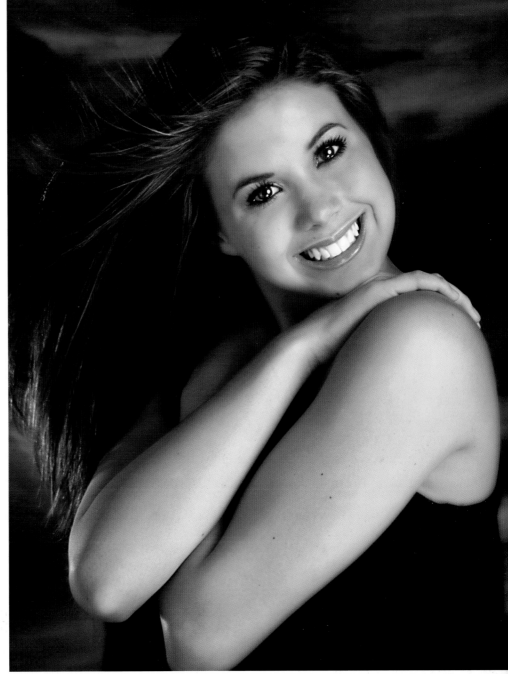

People have to be grounded to feel comfortable and relax.

Subject Seating

Many head and shoulders poses have the subject in a sitting position, so, like most photographers, I use the typical posing stool for many of my shots. This is fine—just be sure to adjust the height of your posing stool so that the shortest person you photograph will be able to touch the ground. People have to be grounded to feel comfortable and relax. If you prefer a taller stool, choose one with a crossbar to rest the feet on (like a barstool). I have a variety of chairs, stools, and ladders available to help add to the variety of poses I can create.

A Fan

When creating a head and shoulders portrait of a woman with long hair, using a fan can increase the drama, boosting the volume of the hair and adding

some motion to an otherwise static portrait. This technique should only be used when your subject has long, thick hair, though; the fan has little effect on short hair, and thin hair tends to look even thinner when blowing. The key here is the hair and not the fan. You can spend hundreds of dollars on a professional fan designed for working in photography—but you'd be a terrible businessperson if you did so. I use one of the commercial floor fans that we have all around the studio (it's hot in Fresno in the summer!). Put it in front of the camera, angle it up toward the subject, and adjust the wind to work with the length and thickness of the hair.

Backgrounds

While what is "typical" in a head and shoulders portrait has changed dramatically, many of these images are still taken with a painted canvas background behind the subject. The styles of backgrounds and the materials used are extensive, so you must be able to change them out quickly to suit your subjects' tastes. We use a background roller system—plus I have an assistant available to change to the backgrounds that won't fit onto the roller system.

Work with an Assistant

Working with an assistant can provide many overlooked benefits. With an assistant, you can get through sessions faster—and the faster you can get through sessions, the more sessions you can do (and the more money in your bank account). Ideally, you should be able to come into each background area you have in your studio and have the basic setup complete, so you can fine-tune everything and capture the images.

Behind the camera, you can make hundreds of dollars an hour for your business; when you spend your time putting up backgrounds and moving sets, you are doing minimum-wage work. The same goes for those photographers who are wasting their lives at their computers. At the computer, you raise your worth from minimum wage to about $12 an hour—but that still won't pay the bills! By hiring someone to do these jobs for you, you can spend your time where it's most valuable: behind the camera.

In addition to saving you money, having an assistant—especially one who is of the opposite sex of the photographer—also makes the client feel more comfortable. If, for example, you are a male photographer, a female assistant can comfortably smooth clothing wrinkles or fix visible bra straps on a female portrait client. This also provides a safer climate to work in, considering the litigious society we live in today. I can't believe there are still photographers out there who will meet with clients of the opposite sex in their home, at a remote location, or in the studio without anyone else around. It's crazy! One bogus allegation of wrong doing and you are out of business. Even if you are later completely cleared of any impropriety, the stigma will follow you.

Working with an assistant can provide many overlooked benefits.

Some of the best assistants in the world are the moms (or dads, or whatever person the client chose to bring with them to the session). The client feels comfortable with Mom around, and holding a reflector keeps her busy so she's not driving her child crazy.

If you don't have (or can't afford) an assistant and know you will otherwise be alone with your client, ask a friend or family member to come with you—even if he or she does nothing but watch your equipment, it protects you.

Beauty Products

In or near the dressing room or restroom you should have basic products for your clients. This includes things like hairspray, hairpins, safety pins, and tampons. (I am not kidding, guys. Unless you have a wife or daughter, you will never know how many times the average woman starts her period at unexpected times in embarrassing places and has no hygiene products.) You should anticipate your client's potential needs and invest a few dollars in products that will add an increased level of professionalism to your business.

Food and Beverages

I also recommend that you have candy or treats at your front counter and snacks and water available for your clients as they are viewing their images. Now, I can hear some people thinking, "What on earth do tampons and water have to do with photography equipment?" To them, I would respond, "Those things mean a whole lot more to your ultimate success than what brand of camera or lighting equipment you use."

More to Come . . .

This is just a partial list of all the equipment I use in any given session. I will discuss equipment in more detail in the upcoming chapters, especially as it applies to lighting and backgrounds. Again, I want to remind you that if you don't have something I do, it's probably just because you are at a different point in your career than I am. I was once so poor that I had a single medium-format camera body with one back and only a normal lens and a 2x teleconverter. I did my outdoor exposures by guess and my studio exposures by trial and error (and a string!). That's *poor*—and it's scary, considering I photographed many weddings this way (and in the days of film, we didn't have instant previews)!

3. Clothing Selection

Most photographers have gotten to a point where they coordinate the basic color of a client's clothing to that of the background, set, or outdoor scene. Darker tones of clothing are paired with darker backgrounds. Lighter tones of clothing are paired with lighter backgrounds. This makes the viewer's eye focus on the person and not what the person is wearing. It also gives you the ability to hide body size, because you don't create an exact outline of the client's body as you would with a white dress on a black background. This is important even in many head and shoulders images, since the arms, shoulders, and chest may be visible in the portrait.

To create a portrait that has a sense of style, you not only need to coordinate the *color* of the clothing to the scene, you must also coordinate the *style* of the clothing, which should present a similar feeling to that reflected in the scene. Although correcting flaws is important to the client, the portrait must also visually "make sense." This can only happen when each aspect of the portrait complements the other.

Clothing Guidelines

Probably the best advice I can give you in regard to your clients' clothing is to have them bring in everything for you to look at. I am not kidding. We tell our seniors to bring in everything, and they do. The average girl brings in ten to twenty-five outfits; the average guy brings five to ten. By doing this, you always have other choices when a favorite outfit is a bad choice for a particular subject.

Long Sleeves. We stress the importance of bringing in the proper styles of clothing. We suggest long sleeves for all portraits that are to be taken from the waist up.

Black and White Clothing. We also suggest that anyone who worries about weight should bring in a variety of darker colors of clothing and several choices that are black. Black clothing is amazing. It will take ten to thirty pounds off of

> We stress the importance of bringing in the proper styles of clothing.

FACING PAGE—Long sleeves are a flattering choice for any portrait that will be taken from the waist up.

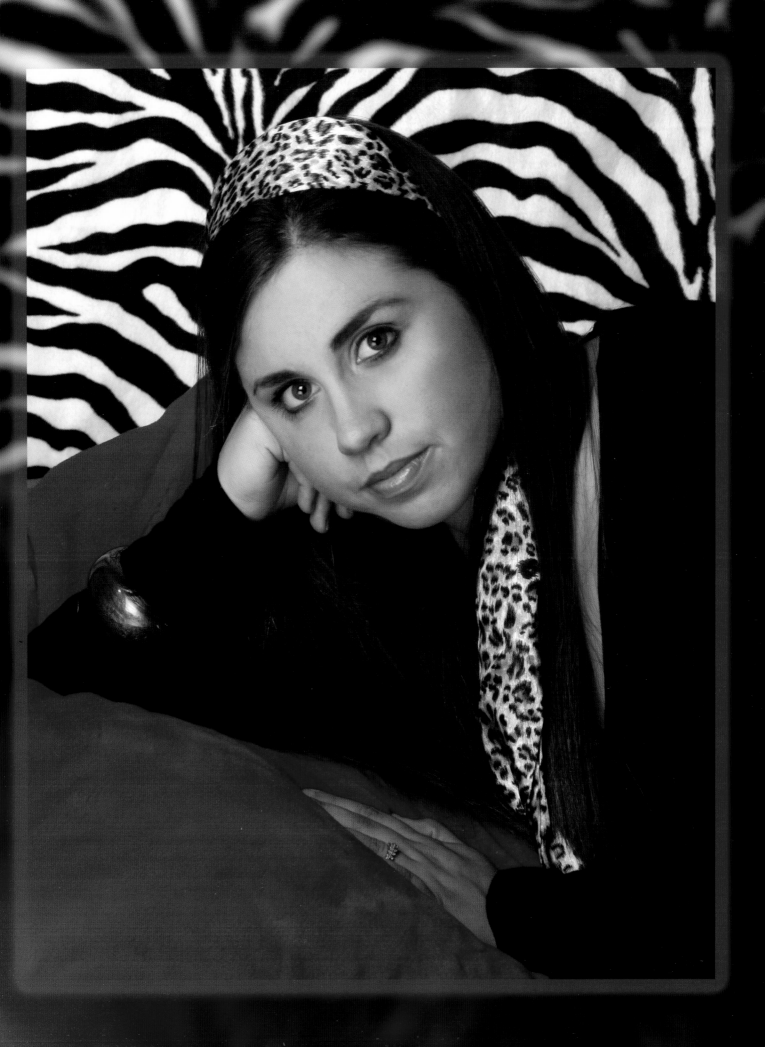

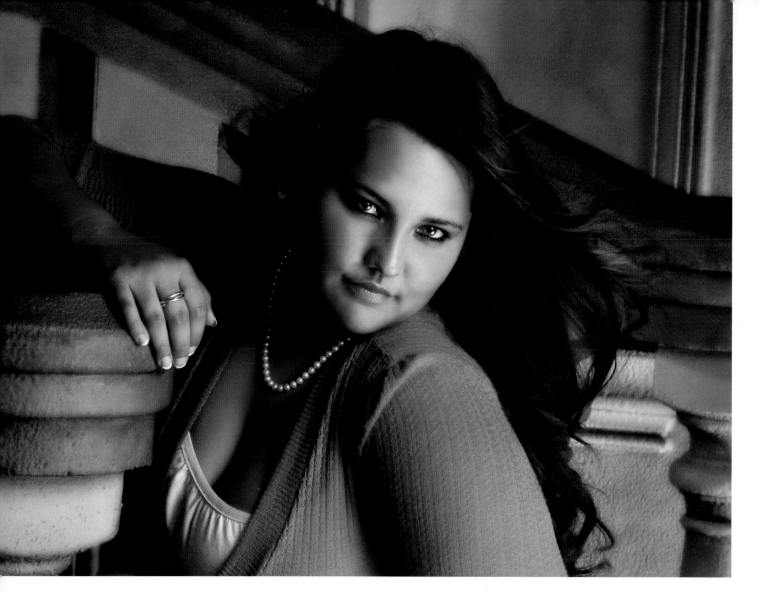

anyone who wears it, provided you use common sense and pair it with a black or very dark background.

A background that is neutral in color will work well with clothing of many colors.

As mentioned in chapter 1, clothing selection usually comes first, then a coordinating background selection is made. However, if the client requests a particular background that contains color, you must be prepared to reverse the process and select clothing colors that coordinate with the colors in the background. Obviously, this isn't always possible, but you can cover your bases by asking every client to bring in one top that is solid black and one top that is solid white. With these two color choices, you should be able to use any background that you have. Black and white are neutrals that will work with any other colors; black works well with all darker colors, while white works with all softer colors and pastels.

Common Problems

With clothing, the easiest way to know what to do is to know what not to do. If you think in terms of all the problems that clothing can create for your clients and then help them avoid these problems, you will learn how to use your clients'

clothing to make them look their best. Here are some common problems that should be avoided.

Poor Fit. Clothing that is too tight affects the subject's ability to pose comfortably. It can also cause indentations in the skin and reveal bulges. Conversely, clothing that is loose-fitting will add weight to the person in the portrait—and you do not want excessive fabric to make a trim subject's arms look large or their waist look thick. (On a similar note, shoulder pads, such as in blazers and suit coats can also be problematic and make your average subject look like a linebacker.)

Wrong Undergarments. Many women forget to bring in the proper undergarments. They bring light-colored tops, for example, but only have a black bra—or they bring in a strapless top and they don't have a strapless bra. In this case, they either have to have the straps showing or not wear a bra, which for most women isn't a good idea.

Unkempt Clothing. Some men (okay, most men) tend to be more sloppy than women, which means that the clothing they bring in often looks like it has been stored in a big ball at the bottom of their closet for the last three months. Many also show up with clothing that used to fit ten years ago when it was actually in fashion. A headshot of a businessman in a rumpled suit or a shirt with missing buttons is not going to inspire much confidence, so this is something to mention to clients before their session.

> Clothing that is too tight affects the subject's ability to pose comfortably.

Strapless tops require strapless bras to look their best.

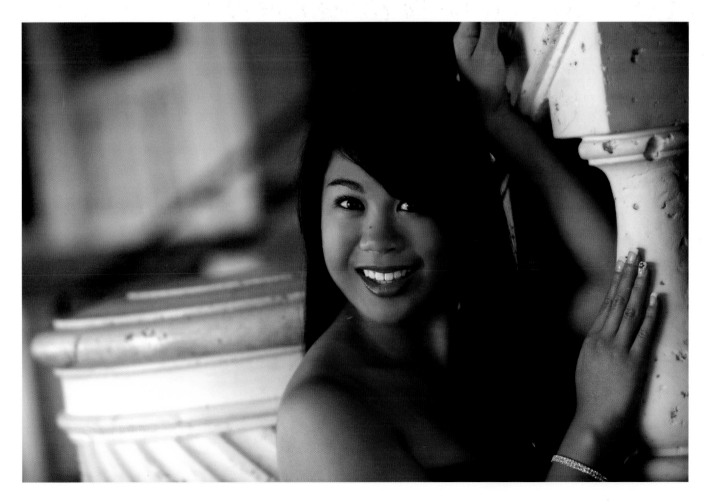

4. Background Selection

The background is an important portrait-making decision, because it makes up a large portion of the image. Background selection also is part of the unique style of each photographer.

Two Schools of Thought

There tend to be two schools of thought when it comes to background selection. First, there is the minimalist approach, which is to use simple low-key and

Plain backdrops create a classic look that helps keep the focus on your subject. These should be one of many background selections you offer your clients.

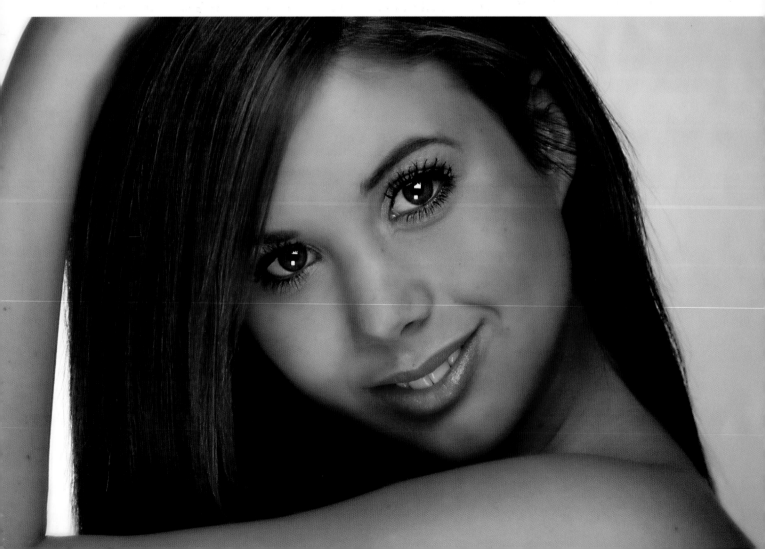

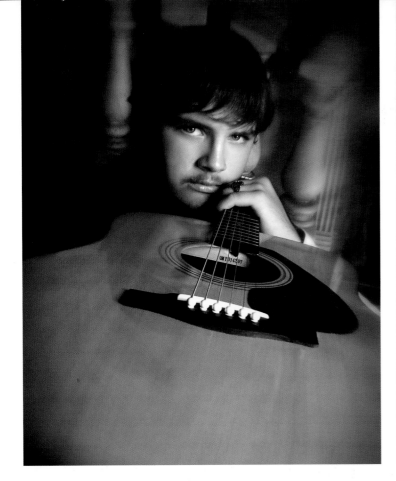

Foreground elements don't have to be built into the set—they can also be personalized props.

high-key backgrounds without texture. Photographers who use this style exclusively tell themselves (and clients) that this is an artistic choice, ensuring that the background doesn't compete with the subject for the viewer's attention. While this is a legitimate point, I've also noticed these same photographers often have a camera room the size of a large closet—so there may be more than artistic decisions at work here. It's not a bad style, but plain black or white backdrops shouldn't be your *only* style.

The second philosophy of background selection is that well-planned backgrounds (and foregrounds) help to enhance the sense of depth and realism in the final portrait. Using this approach requires more space and more planning than the minimalist approach described above, but the variety of looks it allows you to create in your work makes it well worth the effort.

Which style you choose will depend on what your client wants in their images. I've found that I need to use *both* styles of background selection to fulfill the needs and meet the desires of my clients.

Coordinating with the Image Design

The first aspect of background selection we will discuss is the coordination of backgrounds to everything else in the image—especially the clothing.

Contrast. When you coordinate the background to the clothing of the client, you first must consider contrast. Our eyes are not drawn to light or dark. They are drawn to contrast—the smallest area that is in contrast to the largest

area. To those of you that don't believe anything that goes against your college textbook, put a black dot on a white piece of paper. Is your eye drawn to the light (the white) or the shadow (the black dot). Your eyes are drawn to the area of greatest contrast—again, the smallest area that is in contrast to the largest area in the frame.

Controlling the contrast between the background and clothing helps us to control the viewer's eye when they look at an image. Ideally, the face should be the area of greatest contrast. This can be accomplished by pairing lighter clothing with lighter backgrounds (so the face is the darkest area in the portrait) or pairing darker backgrounds with darker clothing (so the face becomes the lightest area in the portrait). In either of these scenarios, the viewer's eye will be drawn to the face and their attention will be held there.

In addition to controlling the viewer' eye, this is one of the principal methods for hiding and disguising the flaws that all paying clients have and don't want to see. Imagine you are creating an image of a young lady in a white dress. If she is larger girl and you know she won't want to notice the outline of her arms and upper body in her head and shoulders portrait, you would photo-

When a subject in white clothing is photographed against a white background, the focus stays on the area of greatest contrast: the face.

 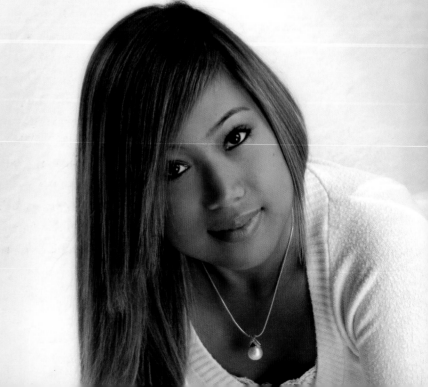

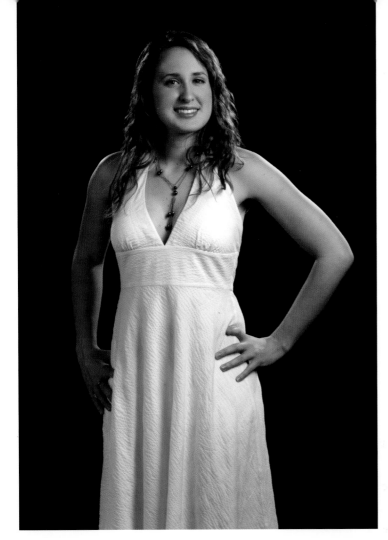
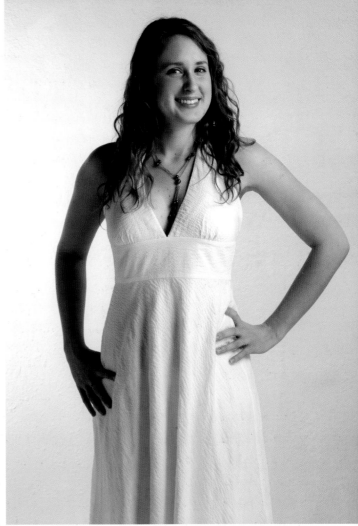

Tonal contrast between the clothing and the background outlines the subject's figure, emphasizing it. Tonal blending between the clothing and the background subdues the subject's figure, keeping the emphasis more on the face.

graph her against a lighter or white background. Because there will be little contrast between the background and her dress, they will visually blend together and leave the emphasis where you want it: on her face. However if the client in a white dress has a perfect figure and wants to show it off, selecting a contrasting dark background would help you achieve this goal. Against a black background, for example, her white dress will stand out sharply and reveal the outline of her body, showing off her shape.

Color. If we only produced black & white images and had complete control of the client's clothing, controlling the viewer's eye would be simple. (In that simple dream world, my Viper would get good gas mileage, too!) In the real world, however, clients bring in the wrong clothing—and the idea of creating just black & white images would mean about 70 percent of our clients would find another studio to do business with.

When we add color, understanding contrast is still important. However, coordination is not as easy to determine as in black & white. As a result, many photographers stick to matching; if a young lady comes in wearing a red sweater, they put a red gel on whatever background they are using. This is a simple way of handling a complex idea, but not all clients want a red background with their red sweater.

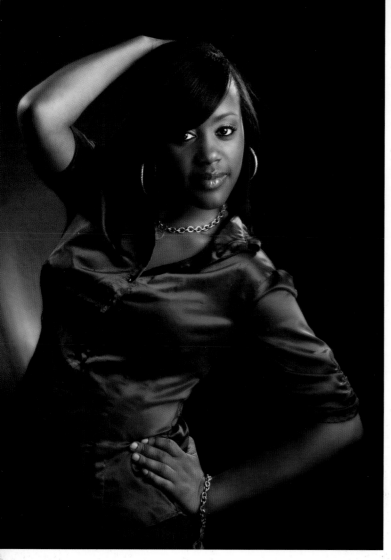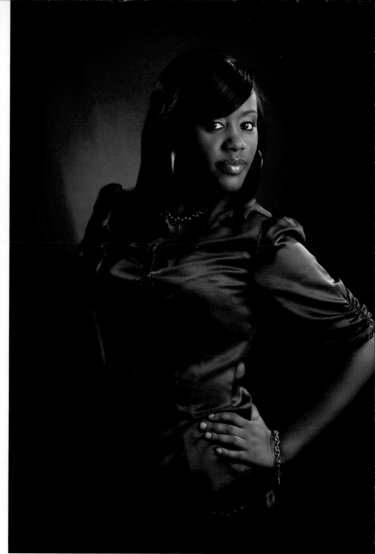

To make my life simpler, I purchase or paint most of my backgrounds as monochromes (whites, blacks, and shades of gray). This allows me to use most of my backgrounds with any color of clothing. Then, I use the amount of light from my background light to control the tone of the background, helping to coordinate it with the tone of the subject's clothing. Monochrome backgrounds also work well with colored gels, when that is something I want to do.

Neutral-colored backgrounds work well with any color of clothing. They can also be gelled to coordinate with the subject's clothing selection.

Lines and Textures. To really complicate the issue, you have lines and textures in many of your backgrounds and in clients' clothing. So what do you do? If you know the answer to that question, please e-mail it to me! Okay, I'm just kidding—but once you have this many variables in the mix, it's easy to see that there are no hard-and-fast rules, just guidelines to make the process easier.

In most cases, when you have lines or textures in the background, the subject's clothing will coordinate best when it does not have a competing texture or pattern. Conversely, when the subject's clothing has lines or patterns, the best background selection will usually be one that does not add a competing texture or pattern. Basically, if the background has lines or texture, the clothing should be solid; if the clothing has lines or texture, the background should be solid.

Of course, rules are meant to be broken—and you'll see examples of such rule-breaking in this very book! It's fine to do this, as long as you know *why* you are breaking the rules. For example, when creating a portrait of a young lady in a top with a graphic design, the basic rule would dictate the selection of a background in a coordinating tone and without texture. However, if you match the graphic top to an equally graphic background, the face becomes the only static (non-graphic) part of the image. This will make it stand out and ensure the viewer's eye is drawn to it. It breaks the basic rules, but it works.

Using Complete Sets

While some photographers are happy to create head and shoulders images using simple materials, like painted canvases and gels, there is no reason not to use sets for head and shoulders portraits—as a matter of a fact, there are many good reasons you *should* use sets! There are two reasons I use sets in my head and

There are many good reasons you should use sets!

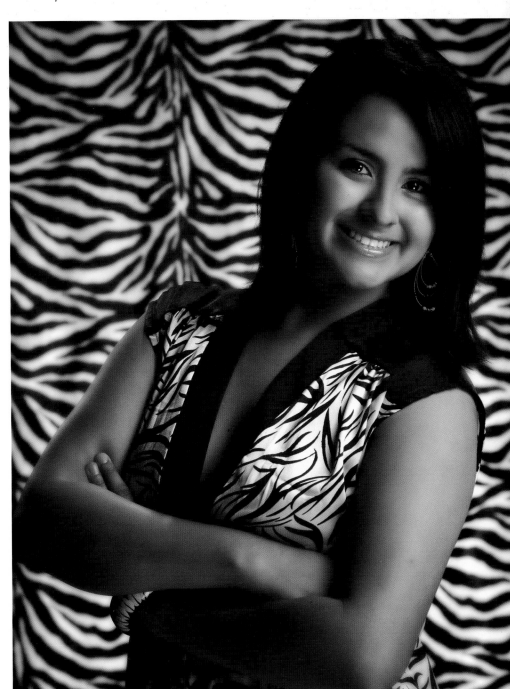

In this image, the subject's graphic top is matched with a graphic background. Because it is the only non-graphic element, and the only element that is not either black or white, her face and skin tones stand out.

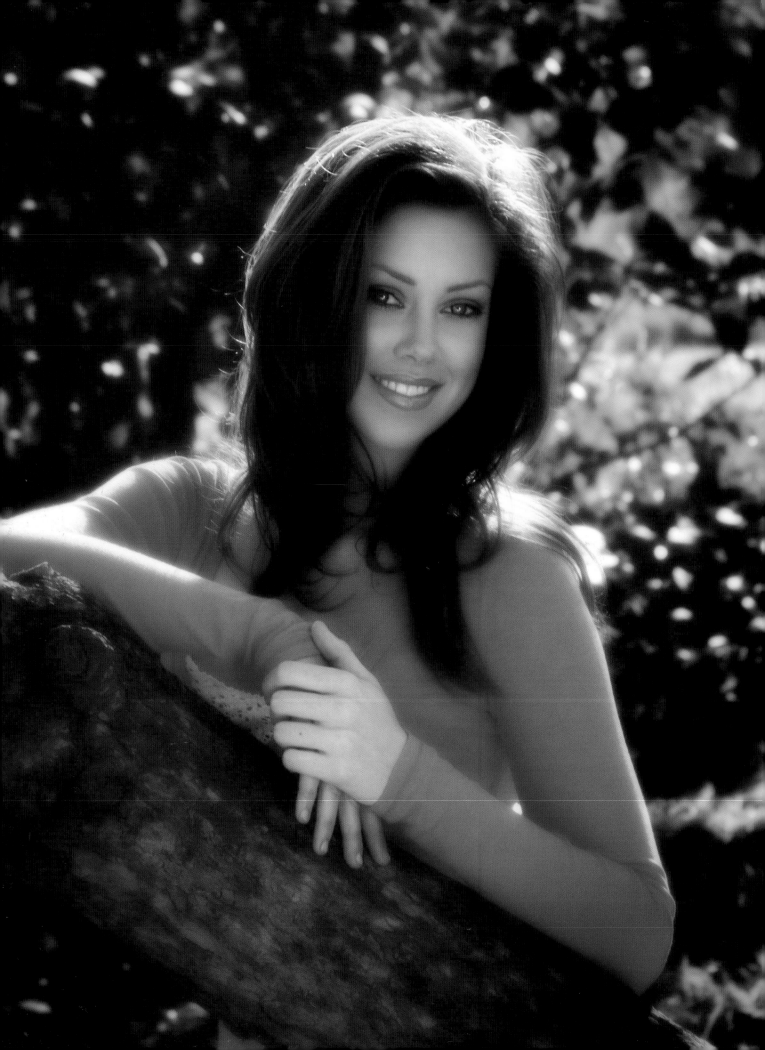

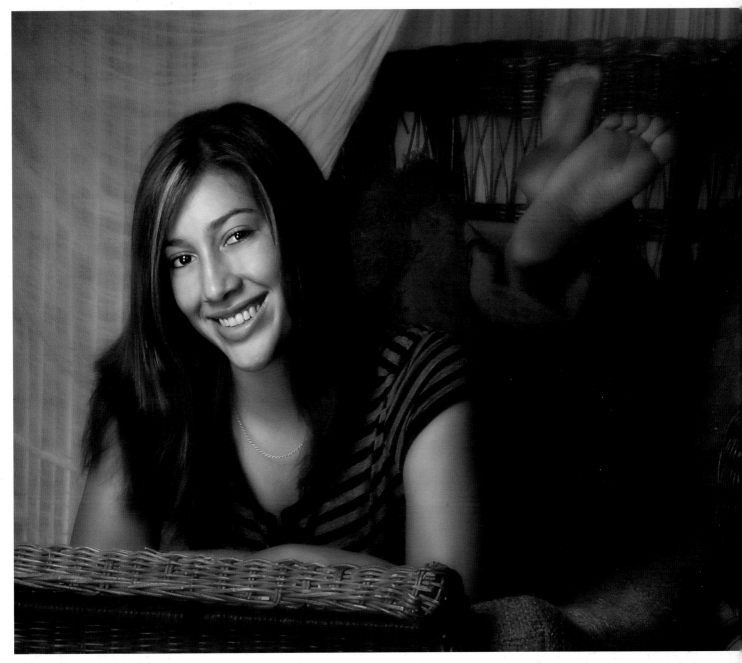

ABOVE AND FACING PAGE—*Including some foreground and background elements enhances the sense of depth and realism. In the image above, notice the girl's feet in the background. Although this might technically be considered a full-length portrait, because her body is so obscured in the background, it's really more of a head and shoulders image.*

shoulders portraits: to create depth and realism in the portraits, which pleases me, and to add interest to the portraits, which pleases my clients.

In the typical portrait, created using a painted background, you have two points of focus: the subject in critical focus and the flat, painted background at one other point of focus (which is obviously slightly out of focus). I like to have four points of focus in my portraits: something in front of the subject in the foreground, the subject in critical focus, and then at least two points of focus in the background. The resulting portrait has more depth and realism.

This idea works in the studio or outdoors. In the studio, you can add a plant or column in the foreground or a swag of fabric between the subject and the background. Outdoors, don't lean the person against the tree with only back-

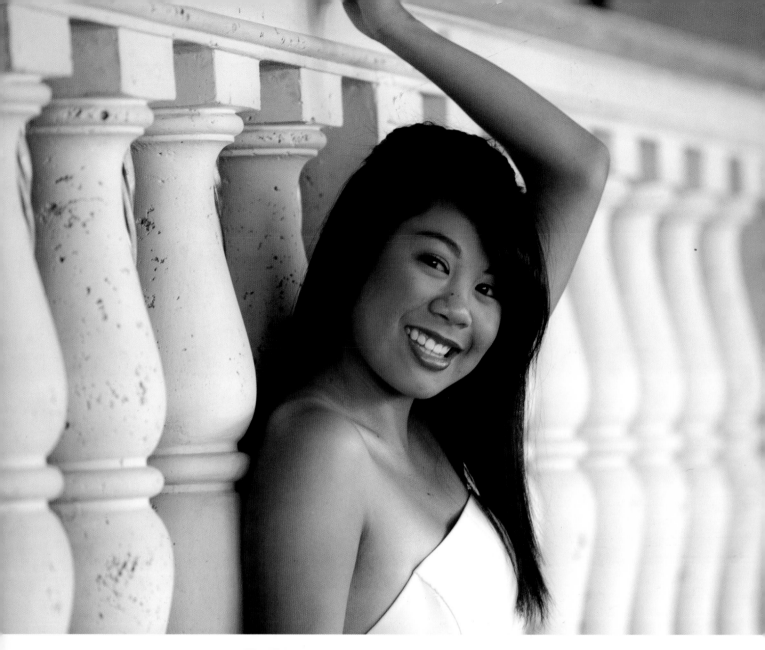

ground foliage in the distance. Position the subject with foliage in the foreground and several points of focus in the background to add realism and depth. (For more on outdoor portraiture, look to my books *Outdoor and Location Portrait Photography, 2nd Ed.*; *Jeff Smith's Posing Techniques for Location Portrait Photography*; and *Jeff Smith's Lighting For Outdoor and Location Portrait Photography* [all from Amherst Media].)

Shooting diagonally into a row of columns provides both a foreground and a background.

Moving Ahead

Background selection is an important part of the head and shoulders portrait. It coordinates with the clothing to help establish the overall look and style of the images—and it helps you develop the look and style that will fulfill the desires of your client. Once the backgrounds for a session are selected, the next consideration is the lighting that will be used.

5. Lighting

Lighting is a subject that could easily fill up several book and take years to completely understand. If you are fortunate, though, you will be in this profession long enough to see your lighting evolve from what it is today to the level you will take it to tomorrow.

Lighting Skills Evolve

Many photographers read my books and e-mail me lighting questions. They are confused because in one book I light my portraits one way, and then they read another one of my books and it says I am lighting my portraits in a different way. That is because, like every photographer, I too am a student. I am learning all the time and everything I learn causes my lighting style to evolve and become more refined. In this book, I am not going to discuss every conceivable lighting style—just the styles that work for me, with my clients.

A Note on Equipment

Let me first start off by saying that lighting isn't about brands or shapes, it's about knowledge. Give me anything—a window and a piece of foam-core covered with mylar; a $15 slaved flash and a $10 umbrella; sunlight and a reflector—and I will create salable portraits that my clients will buy.

The equipment I'll discuss is what I currently use. While it may look a little better or different than yours, it shouldn't change the final image. I will first start by discussing the auxiliary lights I use in the studio before I talk about the main light and method of fill I use. I will also talk briefly about the lighting I use outdoors and on location.

Lighting Descriptions

Before we discuss the individual lights, let me point out that I will not be discussing the specific settings (metered light output) for each light source. In-

> Everything I learn causes my lighting style to evolve and become more refined.

stead, I will tell you the relationship of each light to the output of the main light. The output of the main light varies based on the aperture I want to use, and this is determined by the lens I am using and how soft I want to make the background. There are bold backgrounds that I typically soften, so I may shoot at an aperture of f/4. Other backgrounds, with a softer texture or design, I may want to shoot at f/11. By discussing the relationship of the other lights to this main-light reading, I hope to give you the flexibility you need to make these main-light choices yourself, then fill in the blanks (working in relation to that main-light setting) to achieve the effect you are looking for.

Auxiliary Lights

The auxiliary lights are light sources other than the main and fill lights. In this section, we'll look at what I consider to be the minimal selections for creating a salable portrait in each situation.

Low-Key Setups. *Background Light.* In a low-key (darker background) lighting area, the most important auxiliary light is the background light. The output of this light should be determined according to the light output of the main and fill lights metered together. With the background light set at the same exposure as the main and fill light, the background will pretty much record as it looks to your eye under normal room lights. To lighten or darken the background, you simply adjust the background light accordingly. On my background light, I use the simple parabolic reflector that comes with the light. The placement of the light will determine if the light is even (directed at the background from the subject's shoulder height) or has a gradient effect (light that skims across the background at an angle).

In these photos, you can see how you can direct the viewer's eye to or away from a certain area of a client's body. With the background light low, it draws the eye to the hips and thighs, which is good for some but not for most. As the background light is elevated, the eye is drawn to the waist-line. Finally, with the background light at shoulder height, the focus is the area of the shoulders and head, with the body blending into the background.

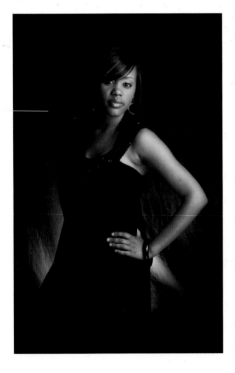
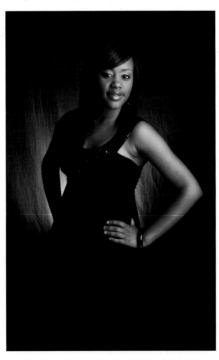
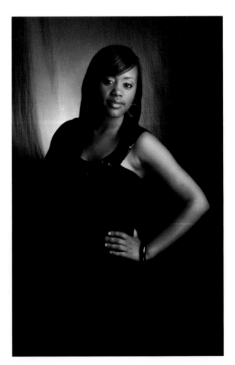

Hair lights are used to improve separation and enhance the luminance of long hair.

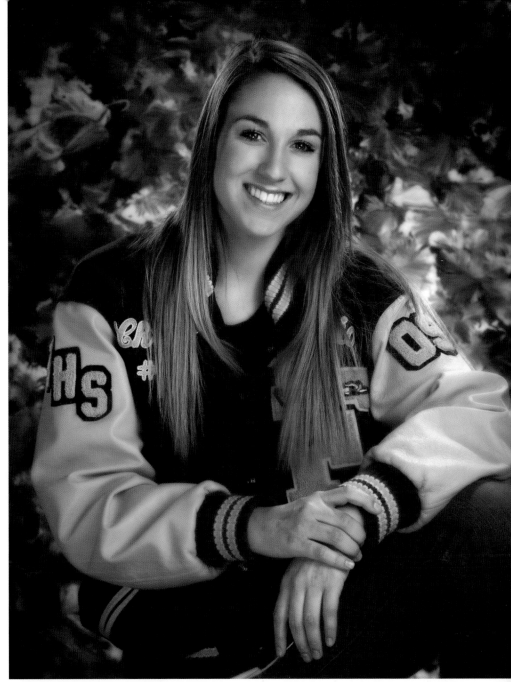

This light should be set to read one stop less than the main light.

Hair Light. The second light that I would consider a necessity in a low-key area would be a hair light. This light is mounted above the center of the background and angled toward the subject's head. I typically put the center hair light about ten feet high for a typical head and shoulders area in which the subjects will be seated or leaning. I place it twelve feet high in areas where the subjects will be standing. Since the light is angled back toward the camera, it should be fitted with a snoot, barn doors, or grid—or even painted cardboard bent around and duct taped to the silver reflector (my method years ago!)—to make sure that no light from this unit reaches the camera lens. This light should be set to read one stop less than the main light. It is possible to get away with not using a hair light, but you will have to use more light on your background to ensure separation at the level of the hair.

Additional Accent Hair Lights. Although it's not necessary, I also use two accent hair lights, placed about seven feet high at the sides of the background and angled down toward the middle of the set where the client will be posed. These lights are used for women with longer hair, adding separation and a luminance to the sides of the hair. These lights are also set to meter one stop less than the main light.

Reflector Under the Subject. For many of my head and shoulders poses, I use a reflector under the subject to bounce light back up from a lower angle. I currently use the Westcott Trifold reflector. For years, I used a drafting table covered with mylar, and before that I used a piece of foam-core board covered with mylar—and both solutions provide a nice look if you're on a budget. I like the effect of having a light come from underneath a subject's face, because it adds highlights to the lips and a lower catchlight in the eyes. It also helps smooth the complexion and lighten the darkness that most of us have under the eyes. Many times, if the reflector seems to be getting in the way, I will replace it with a large softbox on the floor.

High-Key Setups. *Background Light.* The auxiliary light for a high-key area is basically a light to illuminate the white evenly. This actually isn't that impor-

In this setup, you can see the Westcott Trifold reflector placed in front of and below the subject.

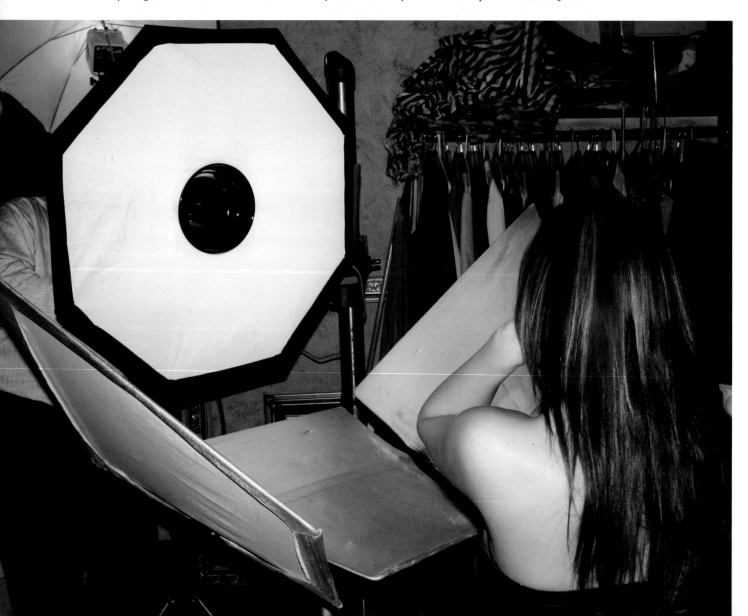

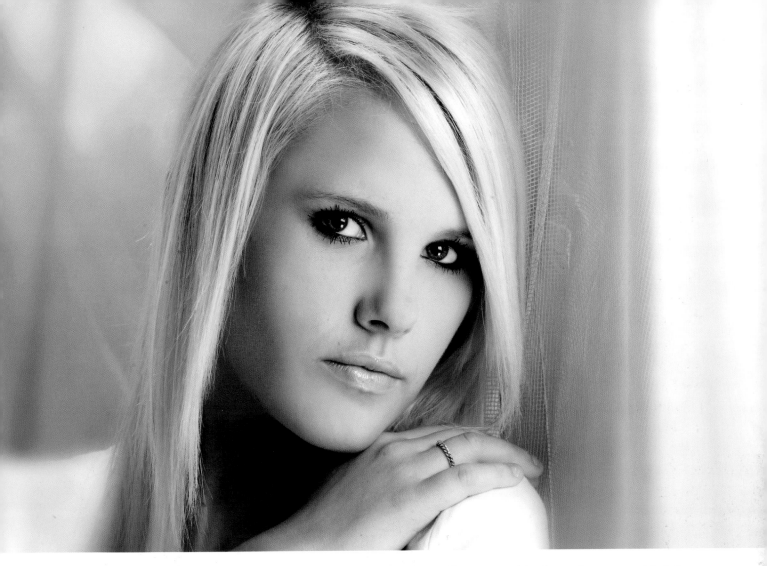

A low lighting ratio creates soft shadows that provide gentle modeling of the face.

tant to me; we have so much traffic on our white floors that, even with daily re-painting, we have to run an action on all our portraits with a true white background and floor to blur the scuff marks and lighten everything to white. As a result, one light from above gives our production department sufficiently even illumination to create a clean look.

If you don't want to worry about applying an action, though, you can set up two lights, fired into umbrellas, on each side of the white area or to each side above the background. Lights illuminating the white background should be set at the same reading as the main light; you don't want that expanse of white to become a reflector, bouncing light back toward the camera.

I personally don't use any accent lights or hair lights in my high-key setups.

Fill Light

In my first books, I used nothing but reflected fill. Then, a few years later, we went digital. With the first digital cameras, I didn't like the look of the shadowing with reflector only, so I used a flash *and* reflected light for fill. Now, in most of my photographs, I am back to reflected-fill only. As I mentioned above, your lighting techniques should always be evolving.

I don't like fooling around with small reflectors, so I have a 4x6-foot silver/white reflector on the side of each camera area. I adjust it for the amount of fill I want with each client, because skin tone makes a huge difference in the amount of fill needed. The choice of white or silver will also depend on the amount of fill you want and the distance the reflector will be placed from the subject. The beauty of using reflectors for fill is that what you see is what you get—so go ahead and experiment to see what works best for you and your clients.

Whether I use flash or reflected fill, I typically shoot portraits at about a 2:1 or 3:1 lighting ratio (this means the main light is 1.25 to 1.5 stops greater than the fill). For images where corrective lighting is needed, to slim a heavy subject for example, or where diffusion will be applied, I may shoot at 4:1 (with the main light set two stops greater than the fill).

Main Light

Distance to the Subject. To understand the main light, you have to understand a few basics. First, the larger the light is in relation to the subject, the softer (less contrasty) the light will appear; the smaller the light source is in relation to the subject, the harder (more contrasty) the light will appear. What this means is that, placed at equal distances from the subject, a large light source (like a softbox) will produce softer light, while a small light source (like a spot light) will produce harder light.

Note, however, the phrase "relative to the subject." This means that even *the same source* can be made harder or softer depending on how it is placed in relation to the subject. If a light source is placed close to the subject, it will be relatively large in relation to the subject and produce softer light. If that same light source is placed far from the subject, though, it will be relatively small in relation to the subject and produce harder light.

Height and Angle. You have two other important controls over any main-light source you select: the height of the source and the angle of the source. Both the height of the main light and the angle of the light in relation to the subject (from the camera position) will determine the sculpting qualities on the contours of the face.

The higher the light is placed, the more it contours the face from top to bottom. However, the higher the light is placed, the less it will illuminate the eyes. Once it reaches a certain height, there will no longer be appropriate catchlights in each eye and dark circles will appear under the eyes.

The greater the angle of the light from the camera/fill-light position, the more it contours the face from side to side. This also increases the shadowing of the side of the face and the size and quality of the transition area from the brightest part of the highlight to the darkest part of the shadow. Additionally, as the angle of the light to the subject increases, the shadow on the side of

> The beauty of using reflectors for fill is that what you see is what you get.

the nose will also grow, thereby increasing the apparent size of the nose in the portrait.

An Individualized Approach. This sounds really confusing, but it isn't. Everyone's face is different and you will need to adjust your lighting for each client in each pose. Some clients have no circles under their eyes and eyes that reflect light really well. In this case, the light can be positioned higher to bring out more contouring of the face. Some people have smaller noses and can have the light at a greater angle to increase the transition area from highlight to shadow.

To determine what is best for your subject, get them in the desired pose and raise the main light to a height that is obviously too high. Then, slowly lower the main light until the eyes are properly lit. At this point, slowly move the main light around the subject until the shadow of the nose becomes a problem, then move it slowly back until you have the best lighting for that person. With the main light adjusted, you can then simply bring in the reflector to achieve the amount of fill that looks best.

Everyone's face is different and you will need to adjust your lighting for each client in each pose.

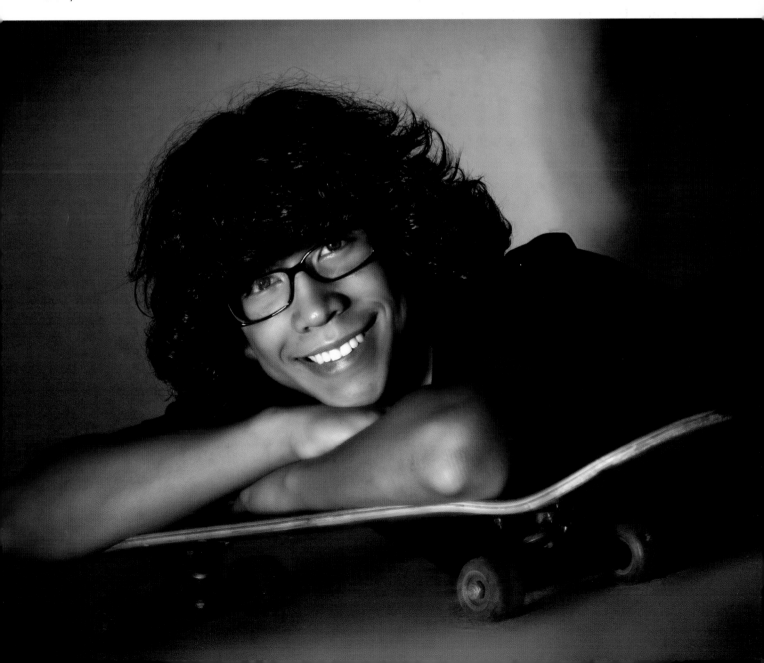

For me, the main light normally ends up with the bottom of the light modifier at about the shoulder height of the subject. The angle is between 60 to 70 degrees from the angle of the camera. (*Note:* Obviously, here we are talking about a standard lighting setup for a more traditional lighting style—at least traditional for me.)

Size of the Light. The light modifier for this style of lighting is a softer light source—like a soft box, octobox, umbrella, or light bounced off a white wall or piece of foam core—of a smaller to medium size. This is because a head and shoulders portrait will have the light placed about four to five feet from the subject. You can use a larger light source, but you will find that you have less control of the light; it will literally flood your camera room and every area of the subject. With a smaller light source, you can put the light only where you want it. In corrective lighting, designed to minimize the appearance of facial or figure problems, I use a very small light box with grids or louvers to have the ultimate control over light placement.

Light Modifiers. Learn to work with the light modifiers you have—and don't think you have to buy a certain light attachment because someone else uses it. Many young photographers make the mistake of thinking that small differences in the shape or interior fabric (white, silver, soft-silver etc.) of a modifier make a big difference in the final outcome of the image. I am here to tell you: they don't.

If you have a smaller light box that has highly reflective silver fabric inside and thin diffusers for the front of the box, the modifier will provide slightly higher contrast lighting, which I find a plus when shooting digital. However, if you want to soften the light from this modifier, you can add the inner diffuser (which most light boxes come with) to soften the light.

Feathering the Light. You can also soften the light by feathering it, which simply means directing the center (brightest part) of the beam slightly in front of the subject and using just the softer light from the edge of the beam to actually light the subject.

You *must* learn to feather light effectively if you are to work with reflectors outdoors. If you reflect raw sunlight into your subject's face, they get an "insta-tan" and burned retinas. However, if you direct the main beam of light slightly in front of or above the subject (this will depend on the angle you are reflecting the light from) you will dramatically soften the light and make it usable for a main-light source. Again, a quality portrait has more to do with your knowledge than your tools.

Test Your Lighting Tools

You must understand the characteristics of the light produced by the equipment you have, rather than hoping there is some kind of magic inside of a new light modifier that will produce the perfect results.

> Don't think you have to buy a certain light attachment because someone else uses it.

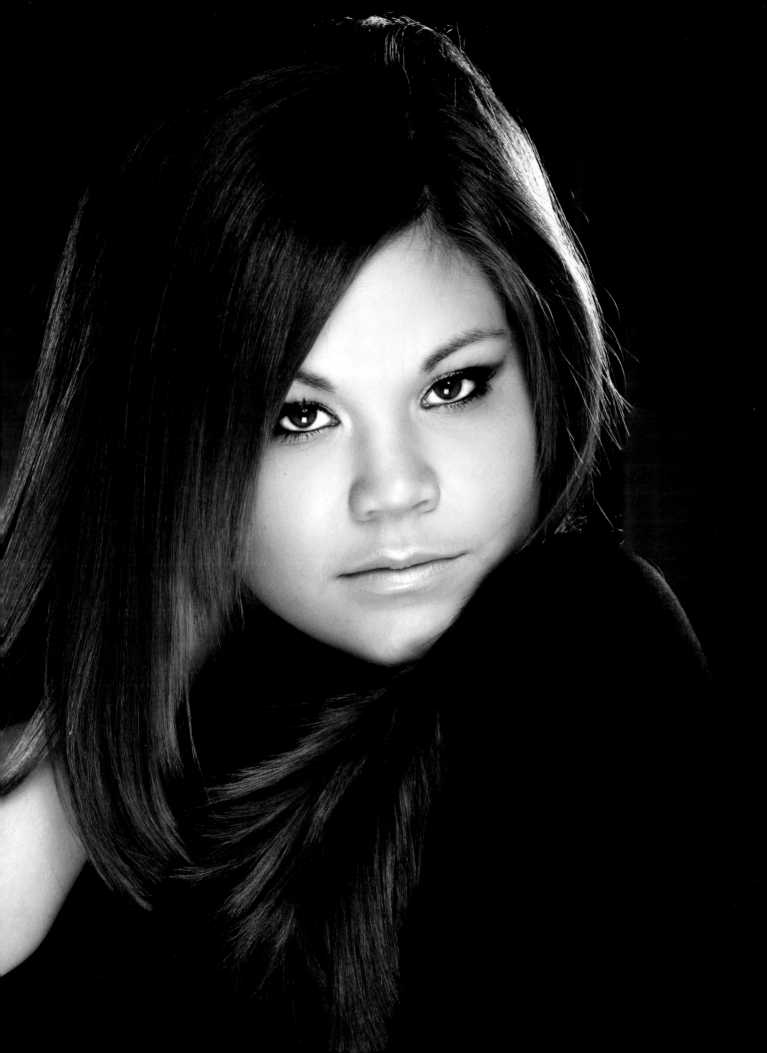

To do this, you'll need to test your lighting so you know exactly what results you will get. It sounds so simple—almost elementary—but very few photographers take the time to test out their lighting completely. When you test your lighting, you start with your single main-light source and no other lights on. Place a light-toned (not white) background behind the subject so that you will not need additional lights for separation. Have all the room lights turned off in the camera area and the windows blacked out; you must be able to *see* your light to *control* it.

Put a test subject in a basic pose and give them a tabletop to lean on so they don't get uncomfortable. Ask them to wear a medium-grey top (white fabric will reflect light up and act as a fill-light source; black fabric will take light away through subtractive lighting).

Start with your light at a 90 degree angle to the subject, then adjust the height as discussed on page 43 and take a shot. Put a piece of duct tape under the main post of your light stand. Then, move the main light six inches closer to the camera position, leaving it at the same height, and take another shot. Again, put duct tape on the floor under the center post of your light stand. Repeat this procedure until your light box is at least to the 45 degree position, with all your marks on the floor. (You may want to keep some notes as to the placement of each shot and the order it was in.)

Next, repeat the process—except this time, adding your fill light. If you use flash, start with a high lighting ratio like 6:1 (the main light three stops greater than the fill). If you are using reflected fill, start with the reflector at a distance where you can see very little fill with your eyes. For a silver reflector, this may be six feet from the subject; for a white reflector this may be four feet from the subject (but a great deal will depend on how you see). Repeat the testing process and mark your reflector with a piece of duct tape on the floor. Now, move your reflector six inches closer and repeat the process, marking the floor. Continue this until the reflector is one to two feet away from the subject—or you have gone in half-stop increments down to a 2:1 lighting ratio.

Once you complete this testing with your first test subject, get a second test subject with the opposite skin tone—meaning that, if you were working with a dark-skinned person, the second person should be fair-skinned, or vice versa. Repeat the complete process (which will go faster since the floor is already marked).

When you have taken all the images, make a print of each test image—a big enough print that you can really see the lighting. Terrible lighting might be overlooked in a wallet-size print or even in a larger print where the face size is small, but with an 8x10, 11x14, or larger print (with a larger face size) you can easily make the distinction between good lighting and bad.

This series of tests doesn't provide you with a "lighting by numbers" kit, but it allows you to set up a range of lighting positions and fill amounts for

Put a test subject in a basic pose and give them a tabletop to lean on . . .

both lighter and darker skin tones—setups that look good to you—while forcing you to get into a habit of adjusting your lighting for each client and each pose.

The reason we only use the main light, and then main light with fill, is to get back to the basic lighting structure. We don't want additional light sources to mask over what is fundamentally bad lighting. The marks on your floor will also help you achieve a similar lighting effect for the desired outcomes during the pressure of a paying session, helping you execute setups that you might forget if you were winging it. (*Note:* If you take a peek at floors in some of the overview shots that appear in this book, you'll notice I don't have tape on my floors. After twenty years, you can peel your tape off, too!)

Consider Unique Sources

Light doesn't change, only the characteristics of lighting change. The same principles of lighting apply to every style of light we will discuss. While the softer light creates a good standard lighting look for general portraits, there are many other choices that provide a unique look in the final portrait.

Parabolics. Parabolic lighting has been used for years by many of the great old photographers, like the late Don Blair. Parabolics are large reflector dishes,

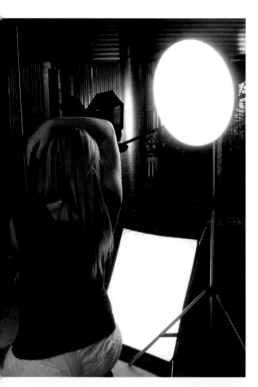

In this parabolic lighting setup, you can see a softbox used below the subject for an extra pop of light.

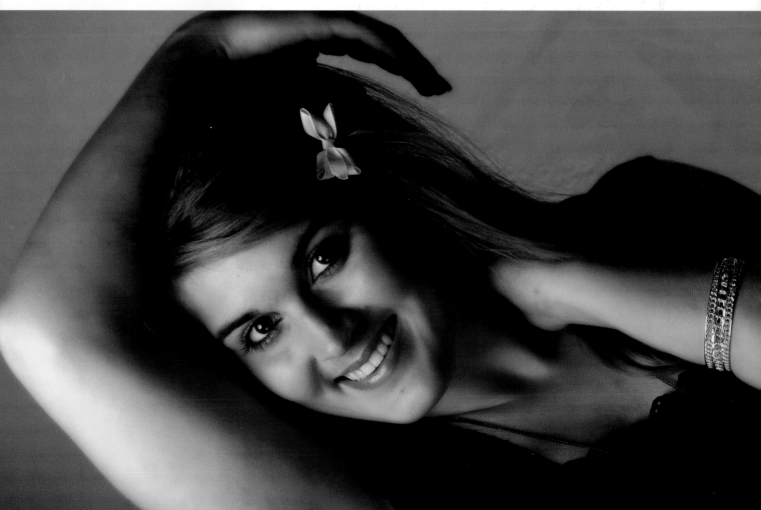

and they offer different lighting characteristic than soft-boxes. If you could imagine combining a soft-box with a spot light, you would end up with something close to a parabolic. The light is harder than the light produced by a soft light source, but it's also more controllable.

I often use this type of lighting when I am diffusing an image. Many times, when photographers diffuse an image, they do nothing differently in their lighting and wonder why their images look "mushy." By increasing the contrast of the image, more of the fine details are preserved when the shot is later diffused.

I also use parabolics for corrective lighting, something I learned by studying the lighting styles of a photographer by the name of Marty Richert. He used parabolic lighting, combined with barn doors and gobos, to block portions of the main light from hitting areas he didn't want the eye of the viewer to notice.

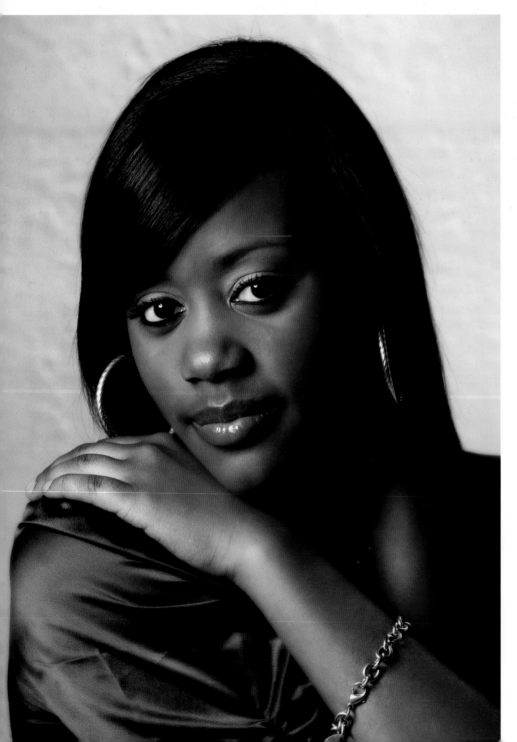

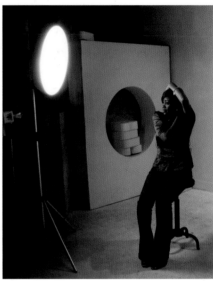

Parabolic lighting offers great control and a crisp look.

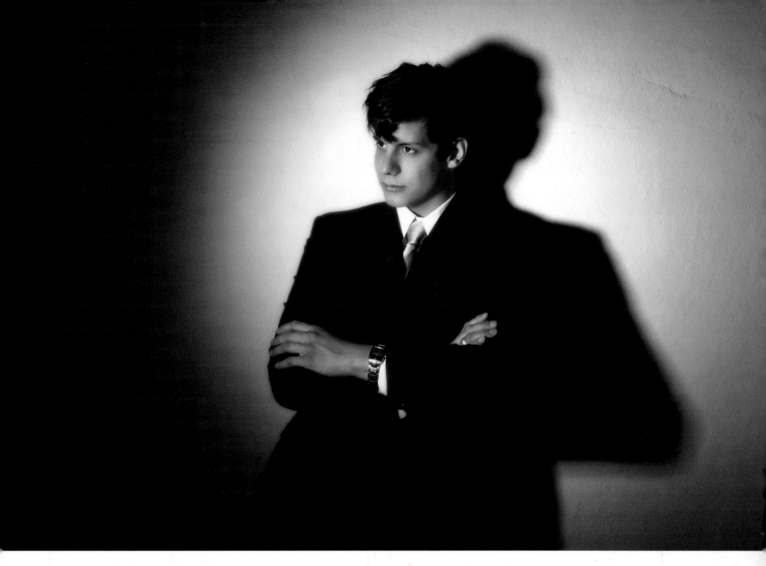

A simple spotlight can create a dramatically lit image.

He used the same technique to tone down lighter areas that were closer to the main light and would record too bright in the final photographs. This kind of previsualization and control is what it means to be a true professional photographer and a master of your craft. Guys like this produced results in their original images that many photographers today could only re-create in Photoshop.

When I work with a parabolic as a main-light source, I typically use a flash for fill. With the added contrast of this type of lighting, reflected fill isn't always sufficient to open up all the little shadows in the nooks and crannies of the face. If you are like me, you will also find that your fill needs to be powered up a little more (producing a lower lighting ratio) than it would be with a softer source. As you test this type of lighting, be very careful about getting proper lighting on the eyes, using your fill light to soften and control the contrast.

While some younger photographers might think this style of lighting has an "old school" look, in this business you quickly find that what was once old becomes new again very quickly. As a result, many of my younger clients find this style of lighting very "classic Hollywood."

Spotlights. The next main-light source we will discuss is the spotlight. Be it a snoot, a spot attachment or a grid, it produces the hardest lighting of all and

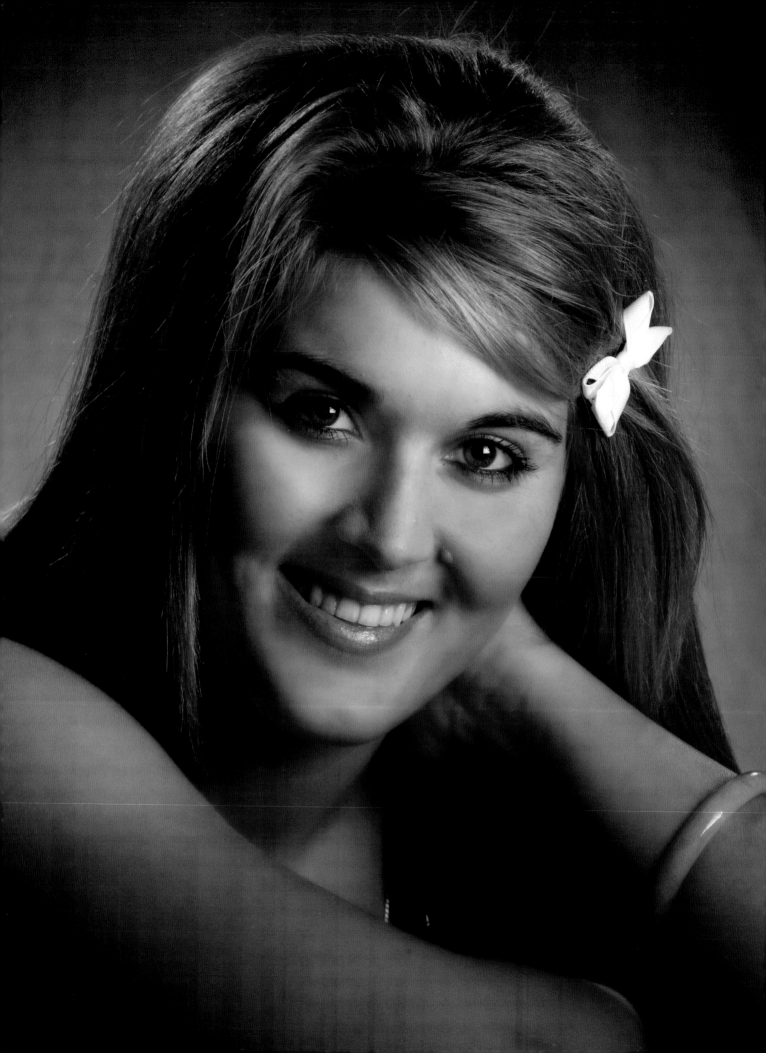

creates an artistic look with strong, heavy shadows. One of my favorite ways to use this light is simply to pose the subject leaning on a white wall with a single grid spot illuminating the subject and background. Whether this shot is taken as a full length or head and shoulders portrait, the look is striking and yet simple. It's not for everyone, but it's a consistent seller.

A spotlight points the viewer's eye directly where you want it. I often use a small spot to just light the basic mask of the face with a slight light falloff around the "edges" of the face. With a spotlight, you have to test the amount of fill used so that you soften the harshness of the look but do not void the effect of the spot.

Lighting for Close-Ups

The next two styles of lighting are the ones we use most often with our extreme close-ups, which are our best-selling portraits. These two styles of lighting have more of a fashion look than a portrait look, but you have to ask yourself: If you had to have your photograph taken, would you rather look like the woman on the cover of a fashion magazine or the woman in the window of the local photographer's studio?

Butterfly Lighting. The most popular of the two close-up lighting styles is butterfly lighting, named for the butterfly-shaped shadow that appears under the subject's nose (well, if you look closely and have a good imagination!).

To create butterfly lighting, the main light is placed above the camera with a reflector or secondary accent light under the camera. The best ratio for the lighting will depend on the facial structure of the person you are photographing and the desired look. At times, I have the lower light (or reflector) at almost the same f-stop as the upper main light. For most of my portrait clients, I have the upper main light about a stop more than the reflector/secondary floor light.

> A spotlight points the viewer's eye directly where you want it.

BELOW AND FACING PAGE—*Using a smaller main-light source that has a grid or louvers gives you complete control over where your light will go and where it won't. The arms of this young lady should be covered, but this smaller light allows us to keep the light off the arms and make them less of a distraction.*

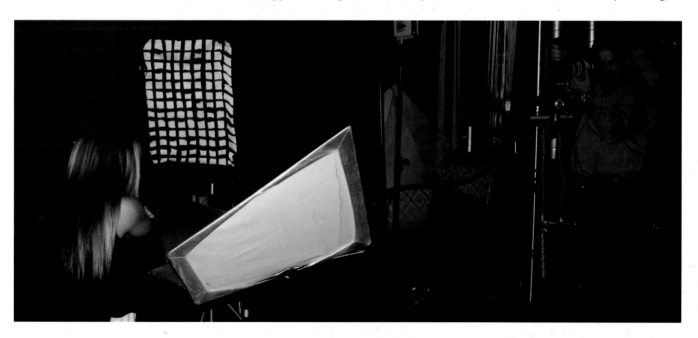

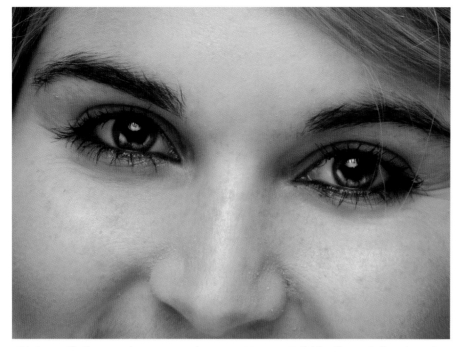
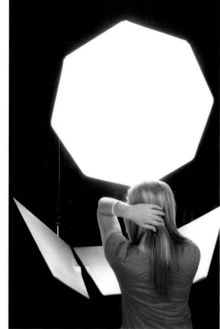

This butterfly-lit portrait was created using a Westcott Trifold reflector below the subject.

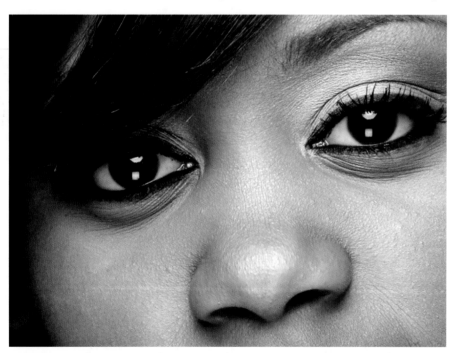

In this butterfly-lit portrait, fill light was created using a softbox on the floor.

The one thing you will notice about butterfly lighting is that, when you *shouldn't* use it on a subject, you'll know it immediately. You will adjust and re-adjust and try to make the client look good with this lighting . . . but it just won't work. It is like the client who's only good side is the back of their head—you don't miss that!

For this lighting style to be effective, you need to ensure that there are pre-dominant catchlights in each eye at both the 12 o'clock and 6 o'clock positions

(or relatively close to those positions). The one mistake that I see many photographers make is placing their lights too close to the subject's head—basically with one light almost on top of the subject and the other directly underneath, which produces a freakish horror-movie lighting effect. Both the main light (over the camera) and the lower light/reflector should be in front of the subject, not above and below the subject.

If you use a reflector as the lower light source, you can control the amount of light being reflected by adjusting the angle of the main light. To increase the light from the lower reflector, simply lower the angle of the main light and more light will hit the reflector.

In some of the overview images, you will notice that I use a boom for my main light in one of the camera areas. This is the area where we do most of our butterfly lighting. While it is possible to use a regular light stand for the main light and move the camera slightly to the side, it can be a real pain when you get the correct angle for the subject only to find that the stupid light stand is in the way. Booms can be expensive if you buy them new, but many times you can find them inexpensively on eBay.

Placing the main light on a boom simplifies the process of creating butterfly lighting.

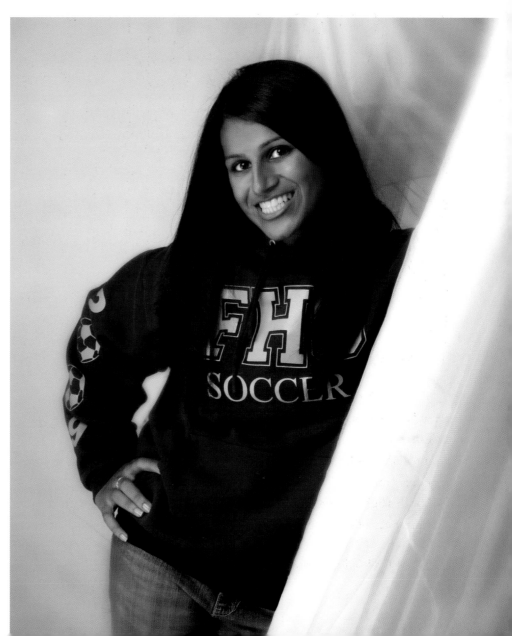

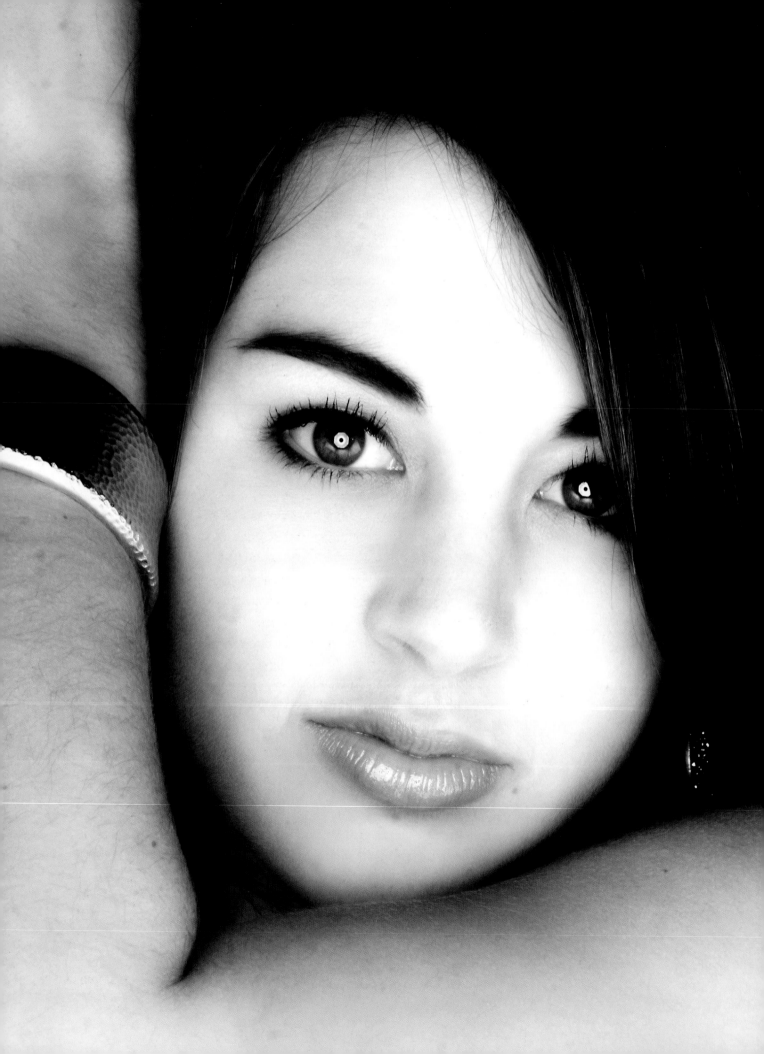

ABOVE AND FACING PAGE—*Using a ring light creates an almost shadowless style of lighting often seen in fashion magazines.*

The lighting effect can be beautiful, but like butterfly lighting it is not for everyone.

While I like the boom, because I like to move the main light to unusual angles and heights, many photographers have a hard time getting repeatable results because the boom allows for *so much* movement. Until you get used to using a boom, or even taking control of your lighting, you may want to employ the string technique for distance (see page 17) and your markings on the floor (see pages 44–47) to help ensure consistency in your lighting.

Another lighting check that I always do occurs when I go through my posing variations. As I will explain in the chapter on posing, I go through a series of poses for the client to select from. When I go into the first pose myself, I look directly at the camera. If I can't see the main light in my peripheral vision, the light is positioned too far to the side (too far from the camera position) or too high. With my lighting style, I know that if I see more than just the edge of the main light in my peripheral vision, the light is not at the correct angle. While this check isn't as precise as the markings on the floor, it is my last chance to check my lighting. (This technique also works on location and outdoors.)

Ring Lighting. The next lighting style is one I noticed becoming popular in commercial photography, and even television commercials, six or seven years ago. They used a large ring light, similar to the ring light used for macrophotography but three, four, or five feet in diameter. The problem was it was thousands of dollars for the light itself—and then I would have to buy the power pack to power it. Between the two, it was way more than I wanted to spend. A few years ago, Larson Lighting (makers of the Starfish) started working on a lower-cost unit—but it was still almost $2000 for a specialty light source. Finally, Alien Bees released a small model that was around $600. At that point, I bought one. It is smaller than I would have liked it, but it works well for the price.

The ring light, whether it's a larger model or a smaller one, works on the same principle as the small "around the lens" macrophotography version; you position the camera in the middle of the ring. The lighting effect can be beautiful, but like butterfly lighting it is not for everyone.

I call these two styles—butterfly lighting and ring lighting—my "pretty people" lights, because it will make pretty people look stunning. If, on the other hand, you try it on a girl who has a large nose, no checkbones, or otherwise looks like Ichabod Crane . . . well, things can get ugly fast.

You're Selling Memories

While these styles of lighting are not all-encompassing, they are the most requested styles of lighting—and therefore the best-selling styles of lighting—we offer to our clients.

Kodak learned a long time ago that they're not selling film, they're selling memories. People will pay more for memories than they will for a piece of film. Unfortunately, photographers often have much loftier delusions when it comes to "their" photography.

First of all, when you are hired by a client, it is not "your" photography, it's theirs. If you think of the photography you create as art, you'll be prone to delusions of grandeur. That's not to say it's not important; you are creating memories for your clients—memories that they will treasure for a lifetime—and that's very meaningful. It's so meaningful, in fact, that they will pay you good money to give them what they want! So choose your lighting styles accordingly.

When all the elements come together to meet the client's needs and desires, your portraits will virtually sell themselves.

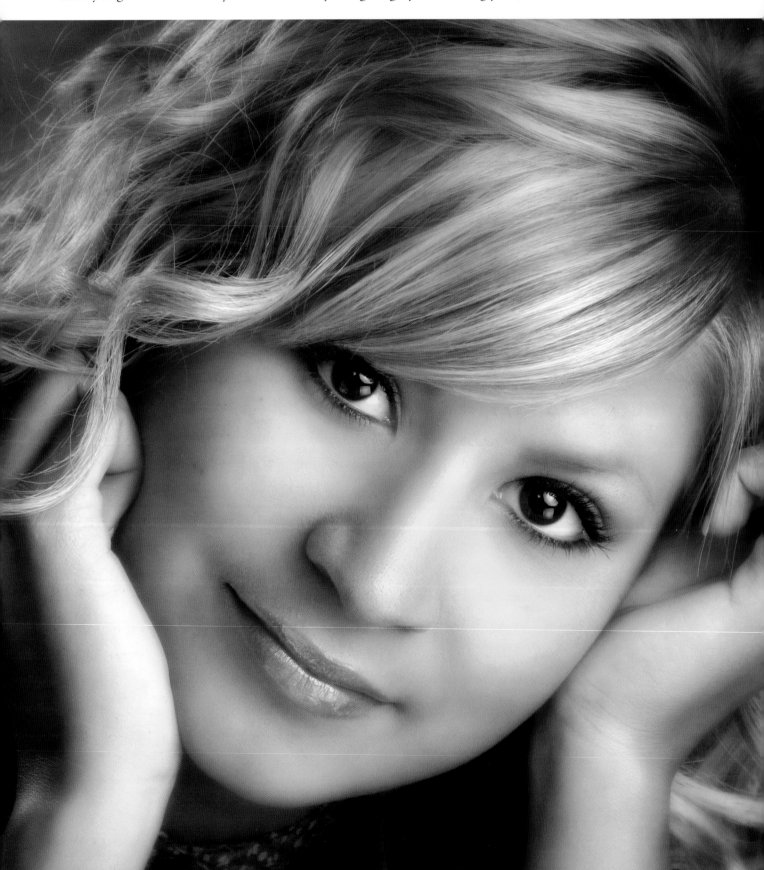

6. Posing

Select a pose that coordinates with the lighting, background, and clothing.

One of the biggest misconceptions about head and shoulders portraits is that very little posing is needed to create a beautiful, salable portrait. In fact, you must select a pose that coordinates with the lighting, background, and clothing to produce a look that will fulfill the client's needs and desires. On top of that, your posing must hide (or at least lessen) the obvious flaws that your client wouldn't want to see. Before we get into corrective posing, however, we'll review the basic components that go into a flattering pose.

Posing is a study of the human form that never ends, because it is a study that is always changing. From my experience, the photographers who have the hardest time creating poses that meet clients' expectations are the young photographers and the older, "well seasoned" photographers. Both tend to pose a client to meet their own expectations and not the client's. If you pose clients in this way, they will never be as happy as they could be, and you will never profit as much as you could by learning to pose for the client and not yourself.

The Head and Face
The Face Turned Toward the Main Light. As we discussed in the previous chapter, I work with a lighting ratio that is approximately 2:1 or 3:1 without diffusion, and 4:1 with diffusion. This means that if the face is turned away from the main light, the shadow on the side of the nose will increase, making the nose appear larger.

If, instead, you turn the face toward the main-light source, whether in the studio or outdoors, you light the mask of the face without increasing shadowing in areas of the face where it shouldn't be. An added bonus is that turning the head also stretches out the neck and reduces the appearance of a double chin, if the subject has one. (*Note:* Decreasing the lighting ratio also reduces unflattering shadows, but it produces a flat look in the portrait. I call this "mall lighting," because the inexperienced photographers employed by most national

and mall photography studios tend to use this very flat lighting to avoid shadows if the face isn't posed properly.)

Lower the Chin, Lose the Catchlights. Lowering the chin produces a more attractive angle of the face, but also requires lowering the main light to compensate. If you don't, you'll lose the catchlights—the single most important aspect of a portrait (from a lighting standpoint). I suggest you elevate the main light to a point where it is obviously too high (with no apparent catchlight) and then slowly lower it until the proper lighting effect is achieved. This forces you to adjust the light with each pose.

The Position of the Eyes. There are two ways to control the position of the eyes in a portrait. First, you can change the pose of the eyes by turning the subject's face. Second, you can have the subject change the direction of their eyes to look higher, lower, or to one side of the camera.

Typically, the center of the eye is positioned toward the corner of the eye opening. This enlarges the appearance of the eye and gives the eye more impact.

The center of the eye is positioned toward the corner of the eye opening to enlarge its appearance and give the eye more impact.

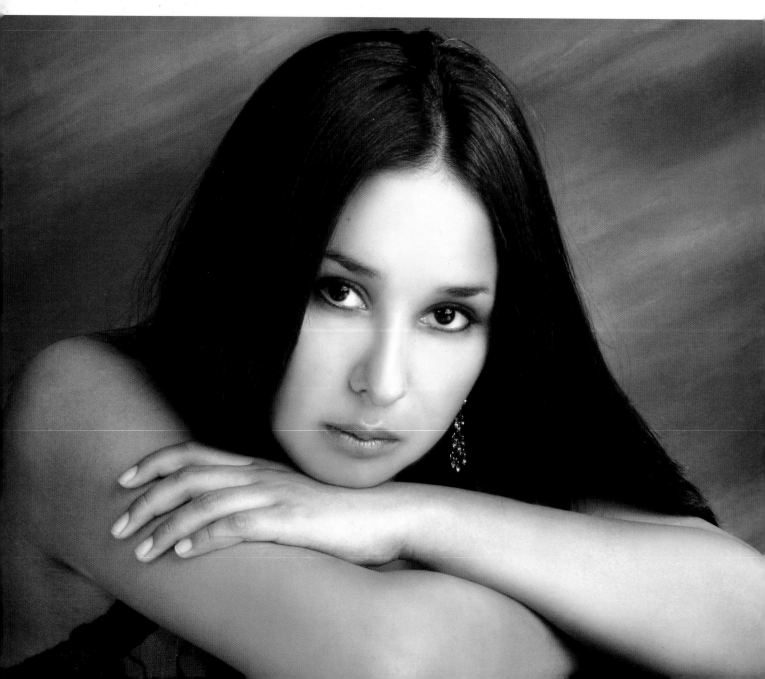

When the subject looks toward the lens, they seem to make eye contact with the viewer. Subjects looking off camera have a more reflective appearance.

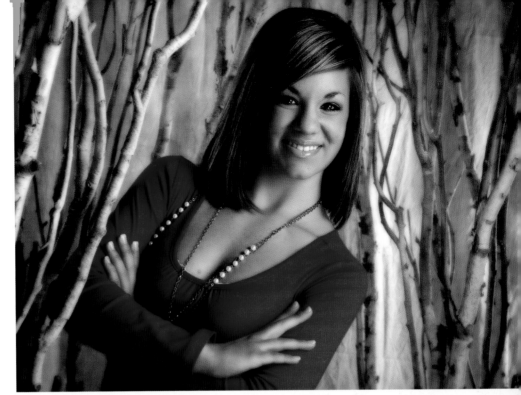

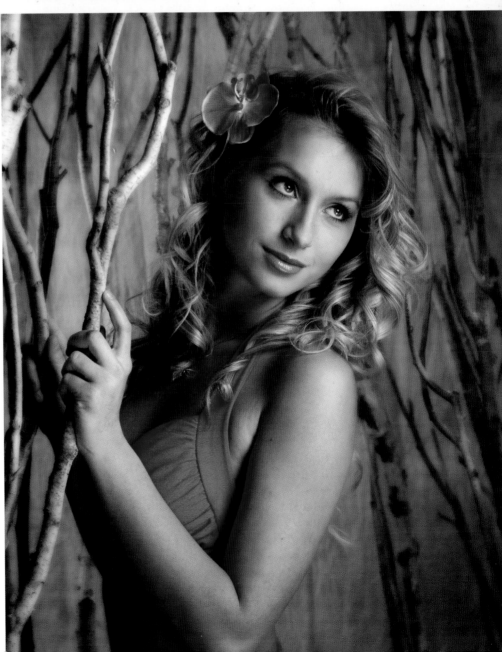

This is achieved by turning the face toward the main light while the eyes come back to the camera. This works well for all shapes of eyes, except for people with bulging eyes. When this is done on bulging eyes, too much of the white will show and draw attention to the problem.

The point at which you ask the subject to focus their gaze in respect to the position of the camera's lens also, in essence, poses the eye. As I've already mentioned, the subject should always be looking at someone, not something. To do this, I put my face where I want their eyes to be. There is a certain spark that the eyes have when they look into someone else's eyes that they don't have when they are looking at a spot on the wall or a camera lens.

Usually, I position my face directly over the camera. This puts the eyes in a slightly upward position, increasing the appearance of the catchlights. If the camera position is too high to make this possible, I position my face on the main-light side of the camera, never beneath it and never to the shadow side of it. Both would decrease the catchlights.

With my face directly to the side of the camera, the eyes appear to be looking directly into the lens, even though the subject is actually looking at me. When looking from the side of the camera, a common mistake that my new photographers make is getting their face too far from the camera. This makes the eyes of the subject appear to be looking off-camera—which is fine if that is the intention and not a mistake.

When the eyes of the subject look into the lens (or very close to it), the portrait seems to make eye contact with the viewer. This type of portrait typically sells better than portraits that have the subject looking off-camera in a more reflective pose. Reflective posing does, however, work in a storytelling portrait—a bride glancing out a window as if waiting for her groom, a senior glancing over the top of a book and thinking of the future, new parents looking down at their baby and thinking of how many diapers they are going to have to change before that kid is potty trained. Well, maybe not that last one—but you get the picture.

If the eyes *are* to look away from the camera, there a few rules that need to be followed. They are really simple rules, but ones that I see broken often. First, the eyes should follow the same line as that of the nose. It looks ridiculous to have the eyes looking in a different direction than the nose is pointing. This goes for poses with the subject looking just off-camera, as well as for complete profiles. Second, as you turn the face away from the camera, there comes a point where the bridge of the nose starts to obscure the eye farthest from the camera. At this point, you have gone too far. Either you go into a complete profile, showing only one eye, or you bring the face back to provide a clear view of both eyes.

The Tilt of the Head. How I wish that every college teaching photography would just avoid this one subject. I have never seen one aspect of photography

FACING PAGE—*When the subject is looking at a person, rather than the lens or a spot on the wall, their expression will appear to be more engaged.*

This type of portrait typically sells better than portraits that have the subject looking off-camera.

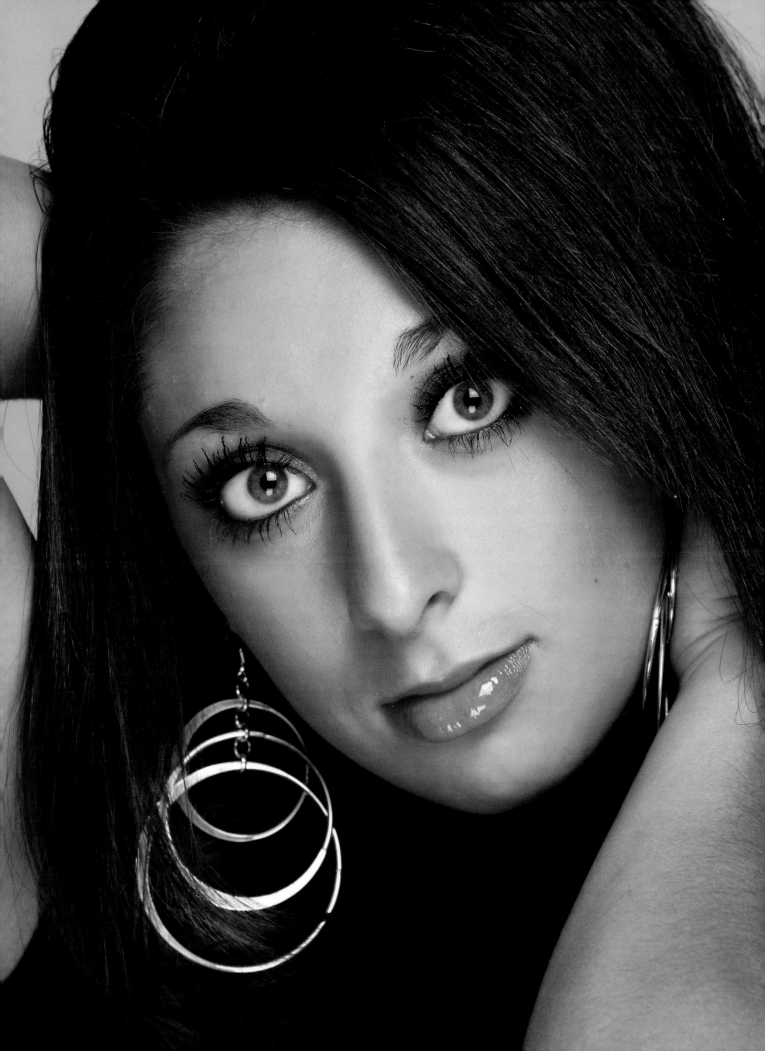

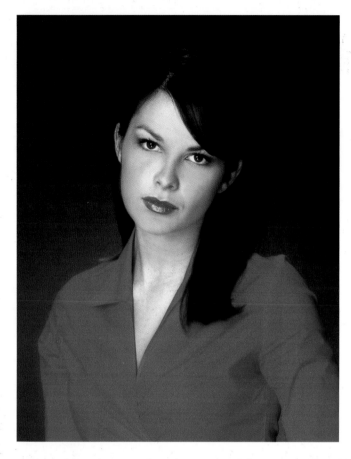
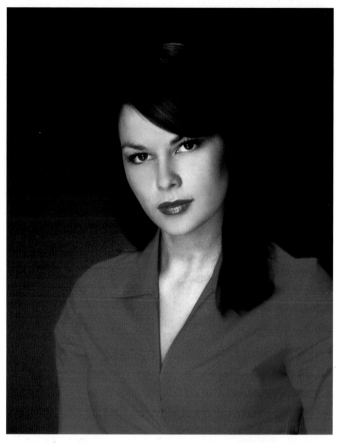

that so many photographers leave school doing so badly. I have seen everything from young ladies who look completely awkward, to guys who look like they were just involved in a car crash that broke their neck.

The Traditional Rules. While many college students will accept that there are different ways to light, pose, and photograph a subject, a lot of them are convinced that there is only one way to tilt the head of each gender—and it's precisely the way their teacher told them! I have had some truly talented photographers work for me, and that is the one obstacle I have had to overcome with almost every one of them.

Which of the above photographs do you like better? If you are like all the people I showed these photographs to, you would say the one on the right. Well, there goes the classic theory of posing shot right in the keister! According to that theory, a woman is always supposed to tilt her head toward her higher shoulder. In this case, tilting the head toward the higher shoulder made her look as though she just sat on a very sharp object and is waiting until we take the picture to get the heck off of it. By tilting the head into what traditionalists consider a "man's" pose, we made her look confident, beautiful, and nothing like a man.

The Real Rule. Now that I have had a little fun, I can continue. The real rule of tilting the head is that there is no rule. You don't *always* do *anything* in photography. If you are photographing a woman, you don't tilt toward the high

ABOVE—*The only difference between these two portraits is the tilt of the subject's head—but what a difference it makes!*

FACING PAGE—*Which direction and how far to tilt the head must be decided on an individual basis.*

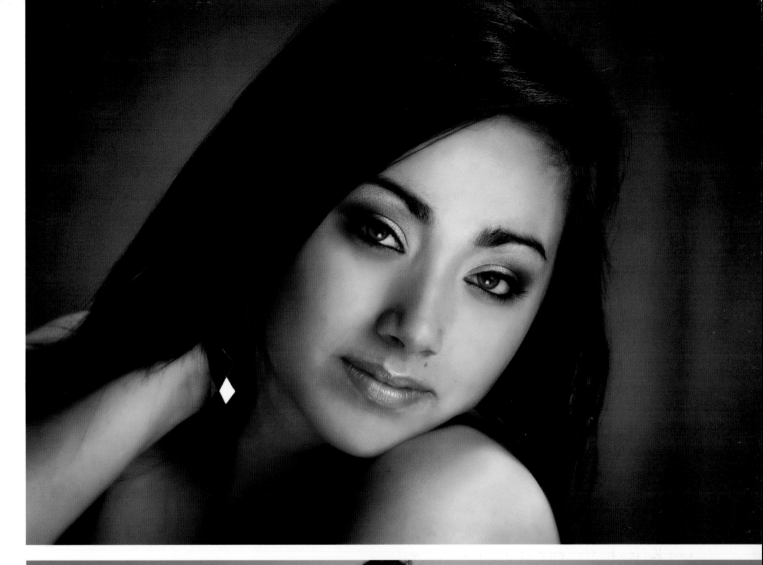
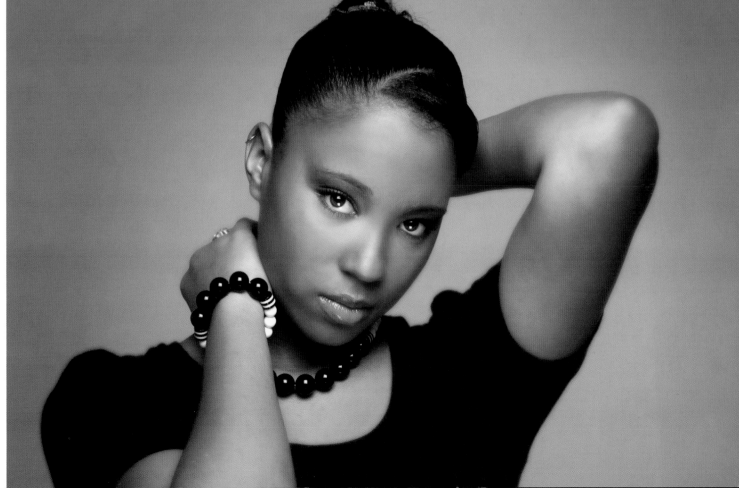

shoulder and you don't tilt toward the low shoulder, you tilt toward the shoulder that looks good.

Long Hair. When photographing a woman with long hair, I look to the hair and not the gender to decide the direction the head will be tilted and the direction in which the body will be placed. Long hair is beautiful, and there must be an empty space to put it. A woman's hair is usually thicker on one side of her head than the other. The tilt will go to the fuller side of the hair and the pose will create a void on the same side for it to drape into. This means she will sometimes be tilting toward the lower shoulder.

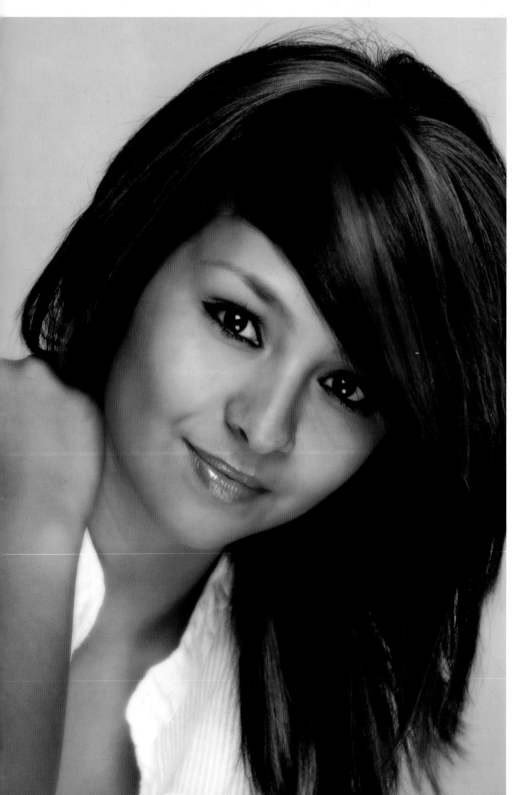

When subjects have long hair, tipping the head toward the fuller side of the hair gives it room to fall into.

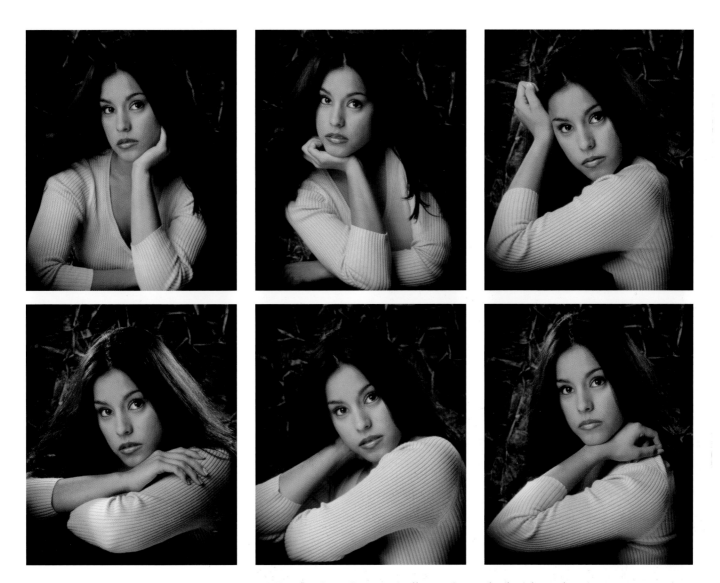

A variety of poses can be used to obscure the neck and the under-chin area.

For the Guys. Guys typically aren't gender benders when it comes to posing; they usually do look better tilting the head toward the lower shoulder or not tilting at all. Again, the pose and the circumstance dictate the direction the head is tilted or whether it is tilted at all.

The easiest way to learn about the head tilt is to first pose the body. Then, turn the face to achieve the perfect lighting and look. Then stop. If the person looks great (as about 80 percent of clients do), take the image. If the subject is very uncomfortable and starts tilting their head in an awkward direction, correct it. It's that simple.

The Neck. The neck really isn't posed and it really isn't part of the face, but there are a few points that should be shared about this area. First of all, the neck is the first to show weight gain and age. In many clients, as you turn the face toward the light, the little cord-like tendons pop out, making the subject look like Jim Carrey doing his Fire Marshall Bob routine on In Living Color (if you don't happen to be familiar with the character, then trust me—it's not an appealing or flattering look). The best way to handle the neck area is to cover

Poses that can be quickly cropped to a variety of portrait lengths are very helpful in high-volume studios.

it up with clothing. If this isn't possible, use a pose that obscures this area from view. (These same neck-hiding poses—several are seen on the previous page—will also conceal a double chin, which can be very helpful.)

The Shoulders and Arms

In a head and shoulders pose, the composition of a portrait looks finished if the shoulders fill the bottom of the frame from one side to the other. If the portrait is composed showing more of the body, then the arms can be used to fill in the void areas at the bottom of the frame. Basically, this is completing a triangular composition, with the shoulders and arms forming the base of the triangle and the head at its peak. (*Note:* Many poses offer the photographer the ability to choose from different compositions. Poses like these work very well in high-volume photography studios. Once the subject is in the pose, you can make a full-length or three-quarter-length image, then move in for a tighter head and shoulders image without having to re-pose the subject.)

The Shoulders. The widest view of any person is when the person is squared off to the camera. By turning the shoulders and torso to a side view, preferably toward the shadow side of the frame, you create the thinnest view of the body. The shoulders of a man should appear broad and be posed at less of an angle than the shoulders of a woman.

Additionally, portrait subjects appear stiff when their shoulders are running perfectly horizontal through the frame or when their spine (if you could see it) is running perfectly vertical in the frame. Posing the person reclining slightly backwards or leaning slightly forward, makes the shoulders and spine run diagonally through the frame for a more relaxed look. The portrait will have a

The widest view of any person is when the person is squared off to the camera.

professional look and it will be more visually appealing. It will also create a more flattering impression of the subject's personality, making them look much less rigid.

Women's shoulders can be a very appealing part of a portrait if posed properly. I like when my wife wears dresses that show off her shoulders. However, my wife is thin and very fit, unlike the majority of people we photograph each day. For this reason, it is always a good idea to have the shoulders covered with clothing if the subject's weight is at all an issue.

Clothing itself, however, can create problems in this area of the body. Large shoulder pads in a jacket, for example, will make just about any kind of posing impossible; your client will look like a football player. As you can imagine, this is good for skinny guys but not so good for larger guys or any woman.

The Arms. Like the shoulders, arms often have problems that are best hidden by clothing, which is why we suggest that everyone wear long sleeves. Models may have perfect arms, but our clients are plagued with a variety of problems—arms that are too large or too boney, loose skin, hair appearing in embarrassing places, stretch marks, bruises, veins, etc. The list is a long one, so cover those things up.

For slim subjects, the shoulders can be an attractive element in the portrait.

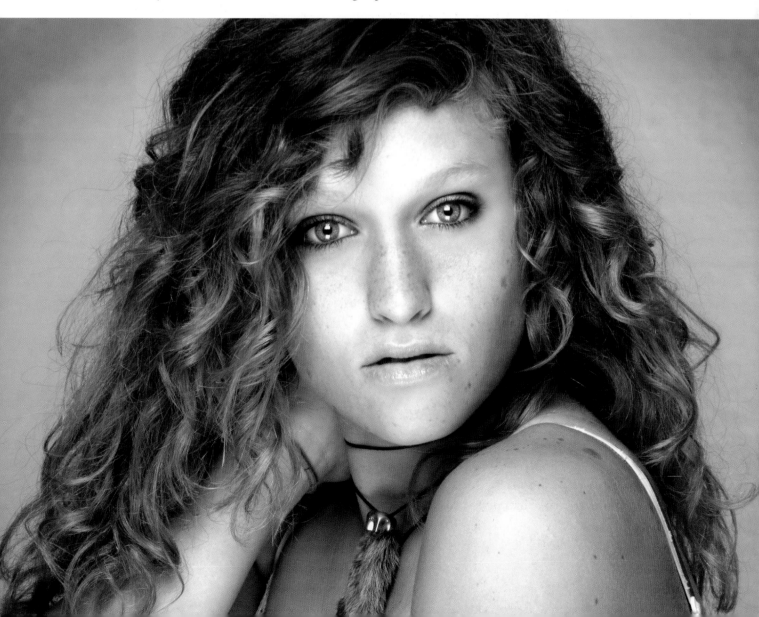

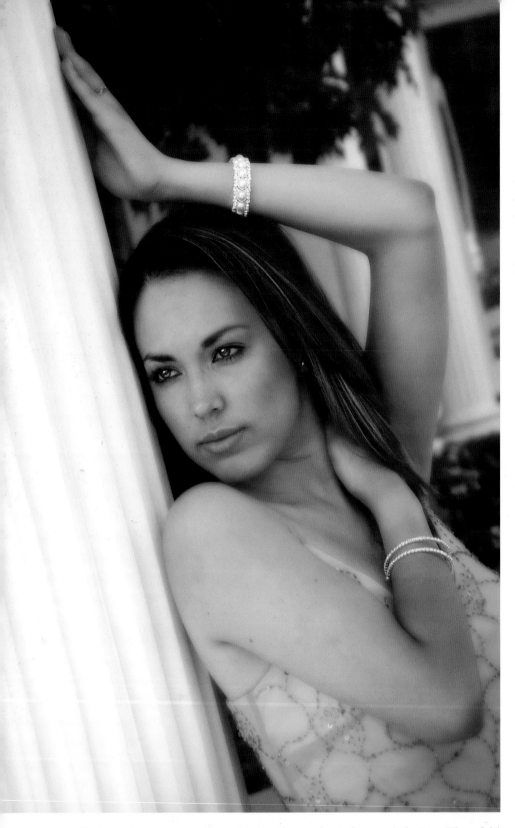

LEFT AND FACING PAGE—*The variations in posing that can be created with the arms are just about limitless.*

To learn how to pose the arms, watch people as they are relaxing.

To learn how to pose the arms, watch people as they are relaxing. They fold their arms, they lean back and relax on one elbow, they lay on their stomachs and relax on both elbows, or they will use their arms to rest their chin and head. However, any time weight is put onto the arms (by resting them on the back of a chair, the knee, etc.) it should be placed on the bone of the elbow. If weight is put on the forearm or biceps area, it will cause the area to mushroom and

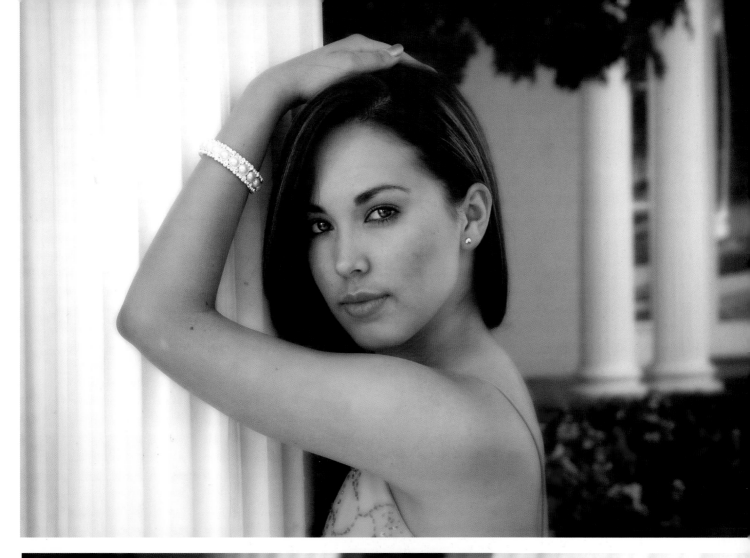
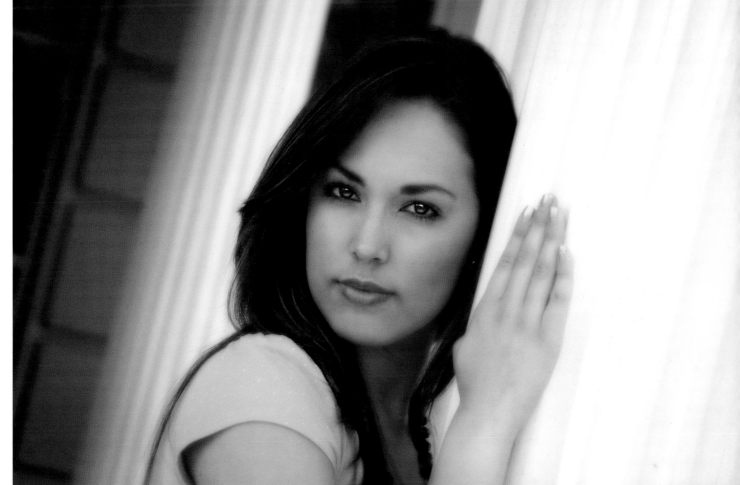

make it appear much larger in size than it actually is. This is another reason to have the arms covered if it at all possible.

The Hands

The hands are one of the most difficult areas of the human body to pose effectively. That's why so many photographers simply stick them in pockets—out of sight, out of mind.

When I first started in photography, the hands were supposed to have every joint bent. As a result, it wasn't uncommon for a woman to look like she'd missed a payment to her bookie and he took a nutcracker to her fingers. Let's face it, the "all joints bent" look is a little on the unnatural side—I don't know about you, but I never have every joint in my hand bent. Using this strategy makes your subject look like a mannequin from the 1960s. Also, when you have the hands posed in such a way, it can draw attention away from the face, the intended focal point of the portrait. While this works well for showing off a wedding ring (or, I suppose, if you are photographing a very homely person with beautiful hands), it is a major distraction for most of your buying clients.

The hands are one of the most difficult areas of the human body to pose effectively.

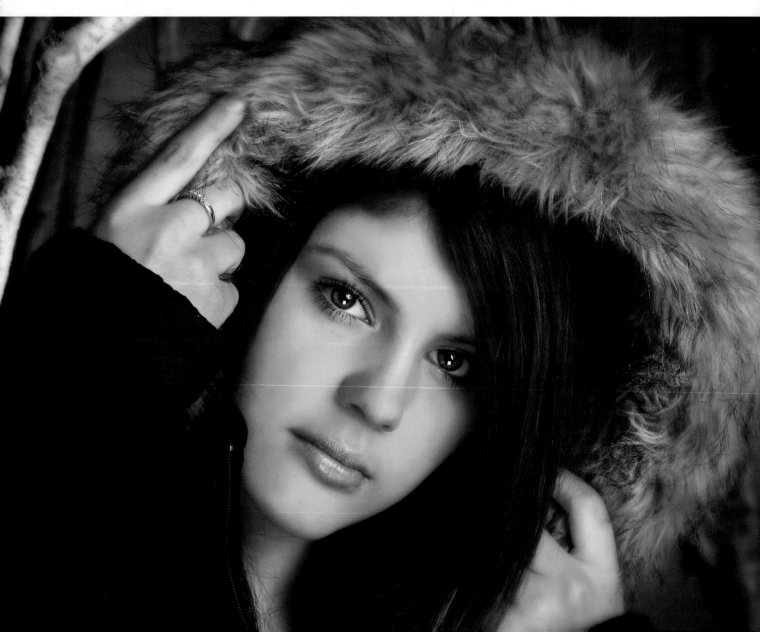

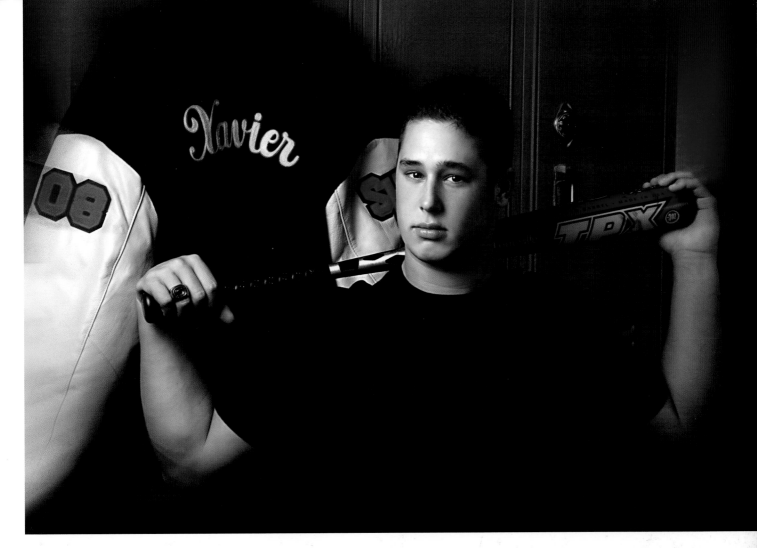

ABOVE AND FACING PAGE—*For both men and women, hands look best when they have something to do.*

Generally, the hands of both men and women photograph best when they have something to hold. They photograph worst when they are left dangling. The hands are one area of the body that clients usually pose very well on their own if you explain where they are to place them or what they are to hold. If you watch people relaxing, in fact, you'll see that they tend to fold their hands or rest them on their body—instinctively avoiding the uncomfortable and unflattering "dangling" positions.

Place the body and arms where you want them, then find a place for the hands to rest, or something for them to hold. Hands hold and they rest, they shouldn't look like they are broken or take on the shape of a cow's udder (with the fingers hanging down). Following this rule simplifies the entire process, allowing you to achieve quick and flattering results while avoiding the very complex process that many photographers go through when posing the hands.

And here's something to keep in mind: Guys don't always have to have their hands in a fist—and if they do, it should be a relaxed fist that doesn't look like they are about to join in on a brawl (if the knuckles are white, the fist is too tight). Women should never have the hand in a complete fist. If a woman is to rest her head on a closed hand, try having her extend her index finger straight along the face. This will cause the rest of the fingers to bend naturally toward

When a subject's hand is shown in a closed position, it should be relaxed, not clenched.

Even the pinky won't curl under to touch the palm.

the palm, without completely curling into it. Even the pinky won't curl under to touch the palm.

The Expression

The first "photography saying" I heard was "expression sells photographs"—and it's true. You can have the perfect pose and the perfect lighting, but if the expression doesn't meet the client's expectations, you won't sell the portrait.

This is another area where photographers frequently make the mistake of thinking they know best. Most photographers like serious expressions with the lips together or glamorous expressions with the lips slightly separated. Among the public, however, mothers are the dominant buyers of professional photography, and they like smiles. Happy sells—and if you want to profit from your work, you had better produce what sells.

Mirroring. Many photographers have a problem getting their subjects to achieve pleasant expressions. Most of the time, the problem comes from the photographer not realizing an important concept called "mirroring." When you smile at a person, they smile back; when you frown at a person, they immediately frown back. People will mirror the expression that you, as the photographer, have on your face.

Our attitudes and outlooks on life set our expressions, and sometimes this gets in the way of making our clients look their best. We had one photographer with us a few years back who smiled all the time. He was great at getting clients to smile, but he would frustrate clients when it came to creating nonsmiling

When you want a smile on the subject's face, you should smile and speak in an upbeat voice (left). When you want a more serious expression, use a more subdued voice and don't smile (right).

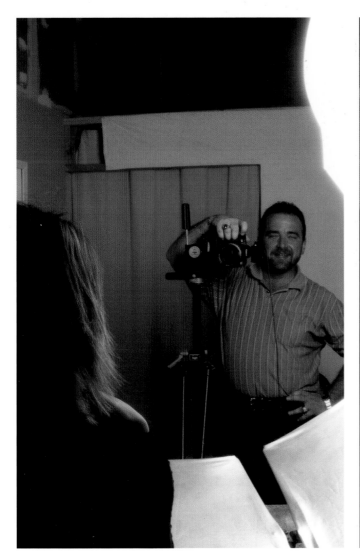

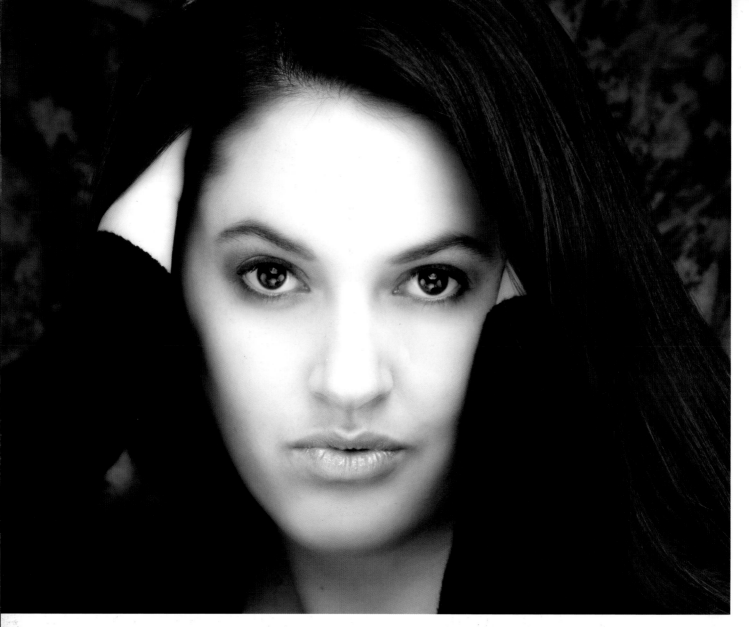

poses. He would tell the client to have a relaxed expression (nonsmiling), while he still had a huge grin on his face. Many clients would get mad and ask how they were supposed to be serious while they were looking at his big goofy smile. A photographer we had before that couldn't smile to save his life. He would look at the client with a deadpan expression and, with a monotone voice, say, "Okay, smile big now." As you can imagine, the clients' expressions suffered as a result.

Mirroring isn't just about visual cues like your expression, it also involves the way you speak. When you are looking at the client with a smile on your face, speak with energy and excitement in your voice. When you want a relaxed expression, soften your voice. In this way, you are in control of every client's expression. Understand the expression your client wants, then take control and make sure that you take the majority of poses with that expression.

The Perfect Smile. Proper expression depends on the age of your clients. With babies and small children, parents love laughing smiles. With children,

ABOVE—*Whether it's happy or serious, natural expressions sell portraits.*

FACING PAGE—*Moms love smiles—but look for a subtle, natural one. Most adults don't look their best with a huge grin.*

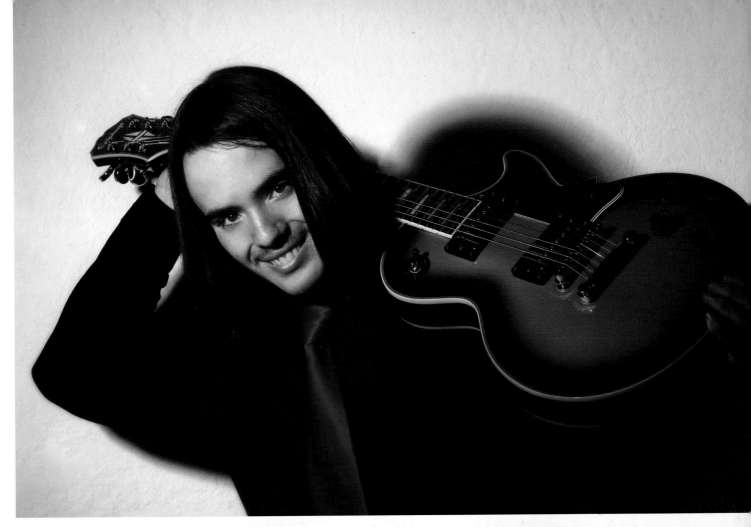
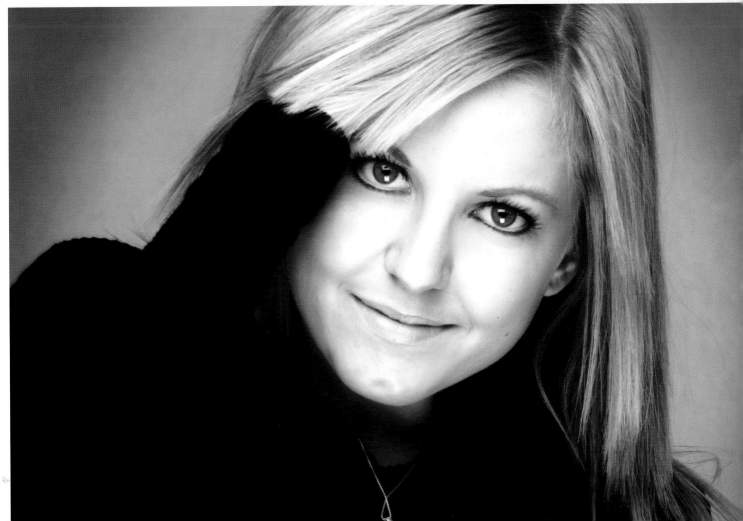

ABOVE AND FACING PAGE—*Gentle expressions and relaxed smiles are the most flattering expressions for most people's faces.*

moody, more serious expressions are salable. In dealing with teens and adults, the best expressions are usually more subtle—happy, but subtle.

While squinty eyes are cute on a baby, not many adults really want to see themselves with no eyes, huge chubby cheeks, and every tooth in their mouth visible. Large smiles also bring out every line and wrinkle on a person's face. Adults are always self-conscious about crow's feet, smile lines, and bags under the eyes—all of which are made much more noticeable by huge smiles. While retouching can lessen these lines on the face, the retouching often reduces the lines too much, resulting in subjects that don't look like themselves.

With smiling, timing is important. It is easy to get a subject to smile, but once your client smiles, it is up to you to decide when the perfect smile occurs and take the pictures. When most people first start to smile, it is enormous. If you take the shot at this point, you end up with a laughing or almost-laughing smile. Once your client has a smile like this, you must watch and wait. A moment after a person smiles that laughing smile, the expression starts to relax. It isn't that big a change, but it is the difference between a laughing smile and a smile that is pleasing to an adult client.

Corrective Posing

Don't Rely on Digital Fixes. Once we went digital, it took our staff about six months to get out of the "we can fix anything" mindset. Every time an employee told a client we could fix something, I would sit them down at a computer station and tell them to fix it. When they were still trying to make the problem area look natural an hour later, I would ask if we could "fix anything" or not.

Time is money and problems need to be dealt with at the shoot, not fixed later. Your client needs to know how to dress to look their best and hide their flaws before the session day. If they don't wear the clothing that you have suggested, then they must be billed for the time it takes to fix the problems that their decision created. This information has to be given to them in writing (in a session brochure) or in the form of a video consultation. We use both, since we want even the most clueless clients to be aware of how they should dress and prepare for the session—and how much it could cost if they don't!

> Problems need to be dealt with at the shoot, not fixed later.

LEFT AND FACING PAGE—When clients are properly prepared, and you take care to choose the right lighting and posing, your images won't require a lot of time-consuming digital fixes.

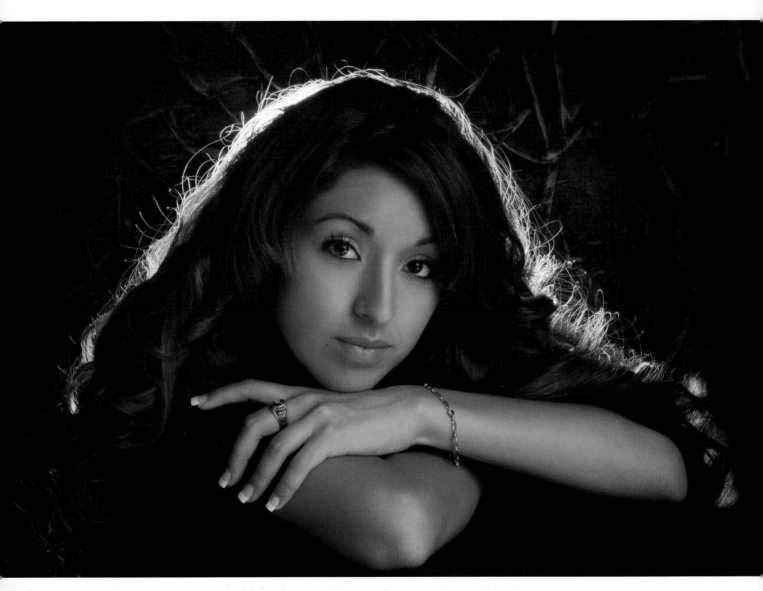

ABOVE AND FACING PAGE—*In poses like these, the neck and chin area is concealed. This is helpful for hiding the area if it's a problem—but the poses also look great for trim subjects.*

Also, If you plan to be in this profession long, you had better consider your clients' feelings about their own appearance and be able to create a preview file that you can show them *without any retouching or artwork*. Photographers are the worst at time-management skills; instead of learning about corrective techniques to hide a client's flaws, many use what is called "pre-touching," which is a process of simple retouching and correction (for flaws) on every file that was taken. Who came up with this one? If there was ever a way to make photography as *unprofitable* as possible, this might be it!

Explaining Problems with Tact. If a client decides not to heed your warnings, potential problems need to be addressed at the start of the session. If you see that your client is a larger woman and you also see sleeveless tops, you need to explain, "One area that women tend to worry about is their arms. This is why we suggest wearing long sleeves. Now, you can try one sleeveless top, but most woman stick to long sleeves just to be safe." This is a nice way of telling your client, without embarrassing her, that her arms are too large for that kind of top.

By referring to other clients and not specifically to her, you save her feelings and the final sale.

Common Problems and Solutions. While there are many problems to correct, even in a head and shoulders style portrait, the following are the major ones. Basically, you'll need to adapt your poses to cover, disguise, or cast a shadow on the areas of the body and face that are problems. You will find that many of the more relaxed poses already hide some of the most annoying problems your clients have.

Double Chin. A double chin (or the entire neck area) is easily hidden by resting the chin on the hands, arms, or shoulders (see the photographic examples shown here and on page 65). Be careful that the subject barely touches his or her chin down on the supporting element. Resting on it too heavily will alter the jawline.

Another way to make a double chin and loose skin on the neck easier on your client's eyes is to stretch the area, pulling it tighter. To do this, turn the body away from the light, then turn the face back toward the light. This will stretch out the double chin so that it will not be as noticeable.

When a traditional head and shoulders pose is needed (for a yearbook, business publication, etc.), it is sometimes impossible to use the hands or arms to hide this problem area. Posing the body to make the neck stretch can only do so much to hide a large double chin. In a case like this, you do what some photographers call the "turkey neck." To do this, have the subject extend their chin directly toward the camera, which stretches out the double chin. Then have them bring down their face to the proper angle. Most of the time, this eliminates the double chin from view. This technique is especially helpful when pho-

> Many of the more relaxed poses already hide some of the most annoying problems.

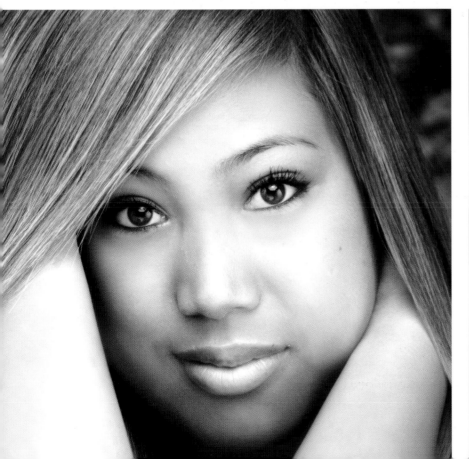
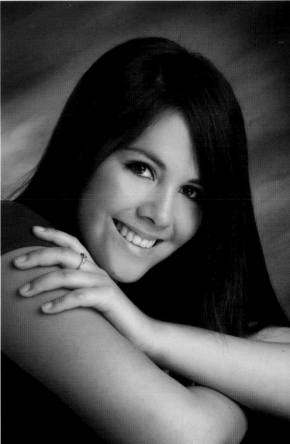

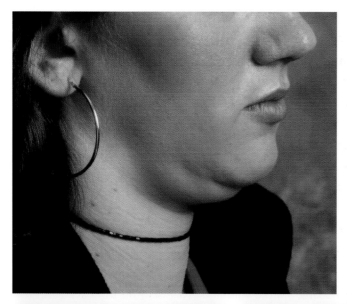

TOP (LEFT AND RIGHT)—*Here seen from the side, the "turkey neck" pose helps stretch out the area under the chin for a more flattering appearance.*

BOTTOM (LEFT AND RIGHT)—*Turn the face toward the main light to conceal the far ear, then reduce the fill light on the shadow side to obscure the other ear.*

tographing a man who is wearing a shirt and tie. Men who have large double chins often also have tight collars, which push up the double chin and make it even more noticeable.

Wide or Narrow Faces. If the subject has a wider face, you can slim it by increasing the angle of the face to the main light. This creates more shadowing on the face. Conversely, if the subject has a very narrow face, you can make it look fuller by decreasing the angle of the face to the main light. In both cases, however, note that this change will result in other lighting changes on the face, such as the nose becoming more prominent as the face is turned away from the main light to slim it.

Ears. Corrective posing is the best way to combat the problem of ears that stick out too far. Ladies who have a problem with their ears usually wear their

hair over them. In this case, make sure that the subject's hair isn't tucked behind her ear, as this will make the ears stand out. Larger ears can also stick out through the hair, making them appear really large.

Without hair to conceal them, the best way to reduce the appearance of the ears is to turn the face toward the main light until the ear on the main-light side of the face is obscured from the camera's view. Then, move the fill source farther from the subject to increase the shadow on the visible ear, or move the main light more to the side of the subject to create a shadow over the ear. Reducing the separation between the subject and the background in this area will also make the outline of the ear less visible. Overhead hair lights should be turned off to avoid highlighting the top of the ear.

In a situation where the ears are so large that they can't be hidden in this manner, you have two choices: either let the ears be seen or highlight only the "mask" of the face, letting both sides of the face fall into shadow.

Noses. The nose is seen because of the shadows that are around it. By turning the face more toward the light or bringing the main light more toward the camera, you can reduce the shadow on the side of the nose and thereby reduce the apparant size of the nose. Butterfly lighting, using the main light directly over the camera and a reflector underneath the subject (see chapter 5 for more on this), can also reduce the apparent size of the nose. This type of lighting compacts the nose by completely eliminating the shadows on each side of it.

Shininess, and the strong highlight that runs down the nose on shiny skin, also draws attention to the size of the nose. Usually, this is only a problem with guys (or when working outdoors on very warm days). Ladies usually wear a translucent powder that eliminates this shine. By keeping a few shades of this powder handy you can save yourself a great deal of time in retouching.

Eyes. Corrective posing can help a client who has eyes that are either too small or too large. Most people want their eyes to look as large as possible. By turning the face to the side (toward the main light) and bringing the subject's gaze back to the camera, the pupil of the eye goes more toward the corner of the eye opening and gives the eye more impact, as well as a larger appearance. With a person whose eyes tend to bulge, however, the face needs to be directed more toward the camera. You must also make sure that no catchlight appears on the whites of the eye, as this will draw a great deal of attention to this area and make it much too bright.

Eyeglasses. Eyeglasses will always be a problem if you don't advise your clients to get empty frames from their eye doctors. Nonreflective lenses make life a little easier, but anytime there is glass in a pair of frames, you end up lighting and posing the subject to make the glasses look good, rather than to make the subject look good.

In our studio, we use a light or reflector under the subject to add a more glamorous look to the lighting, as well as to bring out more of the eye color and

> We use a light or reflector under the subject to add a more glamorous look.

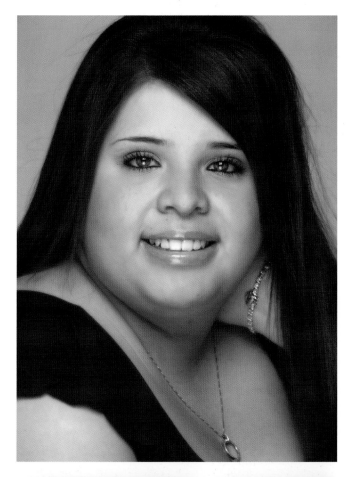

ABOVE AND FACING PAGE—*With careful lighting and posing, you can give your full-figured clients images they will love (facing page)—images the that are much more flattering than the standard portrait (top). The setup for the final portrait is seen in the image above.*

smooth the complexion. With any type of glass in the glasses, this light or reflector has to be removed or it will create glare.

One technique used to reduce glass glare is to angle the frames of the glasses so that the lenses point slightly downward and the frame raises slightly above the ear. This usually reduces the glare and the change of angle isn't noticeable from the perspective of the camera. This isn't an ideal solution, but it is more manageable than spending a fortune on enhancement to remove the glare. A second effective technique is simply to raise the main light to a point at which no glare is visible from the angle of the camera. Here again, though, you are creating the portrait to avoid glass glare, not to make your client look her best.

Baldness. If a client is bald by choice, meaning they have decided to shave their head, they will not usually be self-conscious about it. To photograph them, simply turn off your hair light and you will be fine.

However, if a person's baldness is out of his control, no matter what he might say to the contrary, he is not altogether too happy about it. When you meet with a man over thirty who is wearing a hat or cap, you can be 90-percent certain there is a bald or balding head underneath. To use shadow to reduce the appearance of the balding area, turn off the hair light and lower the camera angle slightly. Then, make sure that the separation light is low enough to just define the shoulders from the background but still allow the top of the head to blend in. At this point, the problem will be much less noticeable.

If a man is really worried about his lack of hair, you can lower the main light and use a gobo in front of the main-light source to hold back some of the light coming from the top of the light modifier. They (and you) have to remember that this isn't an alternative for a hair transplant, though. It doesn't make a person appear to have hair, it just makes the problem less noticeable.

Larger Body Size. The best way to control body size is to have the client wear a black, long-sleeved shirt. You can also rotate the subject's body around toward the shadow side of frame to place as much of the body as possible in shadow. For further correction, use a gobo to block light from hitting the body. As noted in the chapter 4, it's also very helpful to coordinate the color and tone of the background and clothing, allowing them to visually merge, and to avoid using separation lights behind the problem areas.

Posing Styles

Business or Yearbook Poses. Having covered our objectives, let's take a look at the first basic style of head and shoulders portraits. We'll call this business or yearbook posing. This is the classic head and shoulders pose with no hands showing. It doesn't have a lot of style, but it's what most businesspeople and yearbooks still want.

For this image, you have the subject sitting on a posing stool—and for many photographers the posing process ends there. But to add some salability to this basic portrait, why don't we integrate a few of those corrective posing ideas?

First of all, let's turn the body toward the shadow side of the frame to thin the width of the shoulders. Now we have to turn the face back toward the main light, which stretches out the loose skin under the chin/neck. If the subject must look very serious or authoritative (maybe an older businessman or a

For this image, you have the subject sitting on a posing stool.

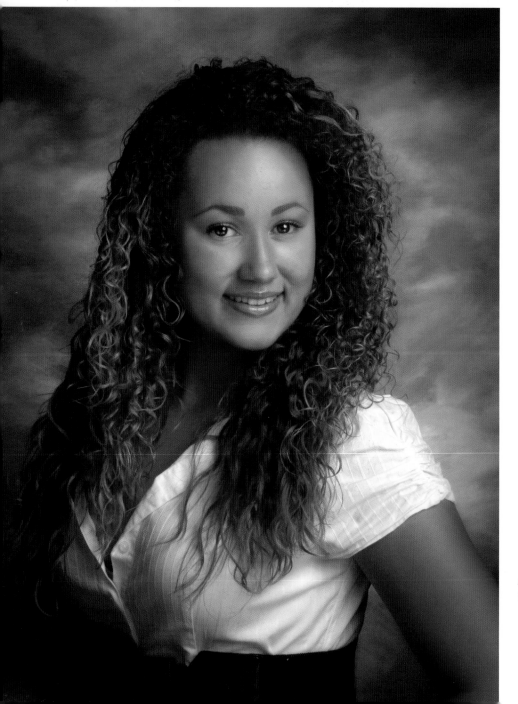

A traditional pose is still what most people want for a business or yearbook portrait.

judge), you would leave their shoulders running horizontally through the frame. However if the subject is a little more fun-loving and personable, you don't want them to appear stiff. To relax the look and make them seem more approachable, make the shoulders run more diagonally through the frame by having the subject lean back on one arm or lean forward to rest their elbow on a knee or tabletop. This gives the subject a more approachable appearance, which is desirable for almost everyone.

At this point, you have used corrective ideas and made the subject look better (a major plus if you intend to sell the portrait!) and you have posed the body to make the person look more likable. Now what? What about using the pose to aid the composition of the portrait? Why not separate the arms from the body to not only define the size of the body (if the portrait is cropped long enough to show it) but to form a base for the bottom of the composition? In this style of photo, nothing looks worse than when the body doesn't fill the frame to both edges. Bringing the elbows out from the body eliminates this problem.

Now you have a basic head and shoulders portrait that a client will purchase. It may not excite you—you probably aren't going to put it on the wall (unless the person is famous!)—but it's salable. We have sold thousands of dollars worth of portraits to a client that only had this style of portrait to choose from. This may not excite you, but your bookkeeper will be happier; she probably has a lot of month left over at the end of your money.

Resting Poses. Be careful to analyze the posing style that a client wants when they say they want a head and shoulders portrait. Many photographers simply stick them in the aforementioned yearbook/business pose out of habit instead of taking a few minutes (on the phone or before the session starts) to find out what they *really* have in mind. The words "head and shoulders" or "from the chest up" don't have the same meaning as they used to. When we hear those words, we think "business portrait." When clients say those words, though, they might be looking in the mirror and thinking how scary a full-length portrait would be!

Listen to the adjectives your clients use as they describe what they are envisioning. When I hear words like "relaxed," "fun," or "natural," I start to think of what I call resting poses. These are portraits that capture the person as they really are when they relax—and they account for 60 to 70 percent of portrait photography sales. Because they are what people actually *buy,* these poses are very important to your bottom line. (*Note:* Earlier, I mentioned that the most-*requested* portraits are the extreme close-ups that have a more sexy/fashion look. However, there is a limited market for those "sexy pictures." They're fine for impressing your friends or significant other, but not so good for Grandma, business cards, and all the other ways people use their portraits. Therefore, the bigger market lies in the portraits that capture the person as they really are.)

Listen to the adjectives your clients use as they describe what they are envisioning.

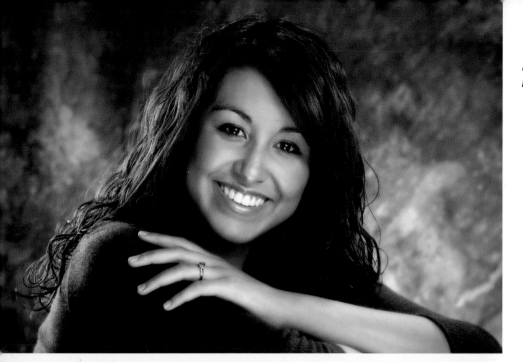

Resting poses look natural and show people as they are when they are relaxed.

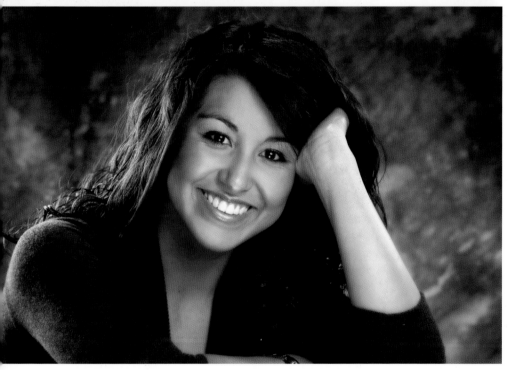

To create relaxed poses, I typically start off with the subject seated on the floor.

Resting poses show the subject in relaxed positions, similar to those positions they would put their own body in when relaxing at home or at the park. When people relax, they lie down or recline back. They use the ground (for lying down), or the couch, or seat to support the major parts of the body. The hands, arms, and legs then tend to support the head and shoulders. While posing books come in handy, so does people-watching—especially at times when people are relaxing.

To create relaxed poses, I typically start off with the subject seated on the floor, either reclining or leaning forward. When the subject is lying on the floor I have them either on their stomach or on their side. I then use the hands and

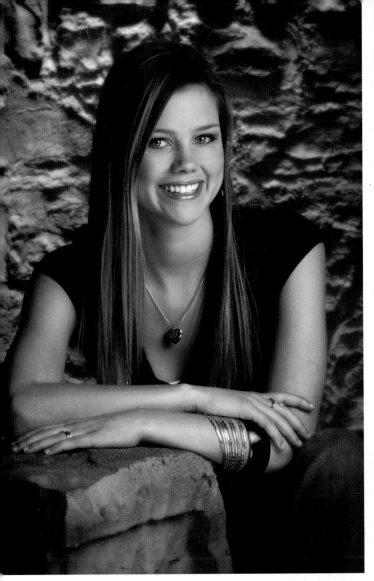

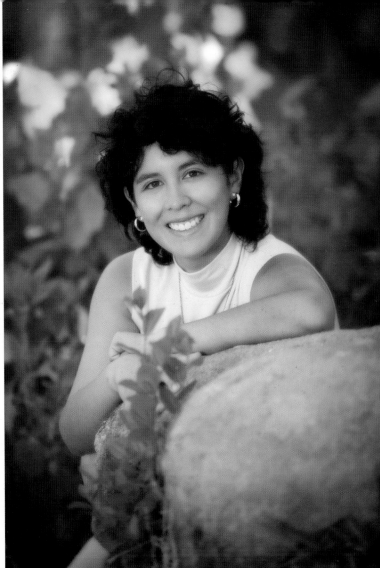

To learn how to create resting poses, watch how people position themselves when they are relaxed.

arms to support the face and/or shoulders. The process is very similar for reclining seated poses or poses that have the subject leaning forward.

Glamorous Posing. When I hear "sexy," "glamorous," "alluring," "attractive," "as beautiful as possible," or "like the girls on the covers of the magazines," I turn to what I call glamorous posing. Many photographers see the phrase "glamorous pose" and think of images that have the clients' breasts popping out of their clothing or a guy with his shirt off, exposing his muscles—but the same emotional responses these images create can actually be generated in a head and shoulders pose that reveals nothing more than the hands and face. Essentially, glamorous poses are the opposite of resting poses. Resting poses show the person as they really are; glamorous poses show the subject as they wish they were.

The idea behind glamorous posing is to give the client something like what they see in beauty and fashion magazines. Our clients are exposed to the coolest, sexiest, most appealing images ever created. Every month, in every magazine they pick up, they see images created by some of the world's best photographers. Still, many photographers never understand the impact that these im-

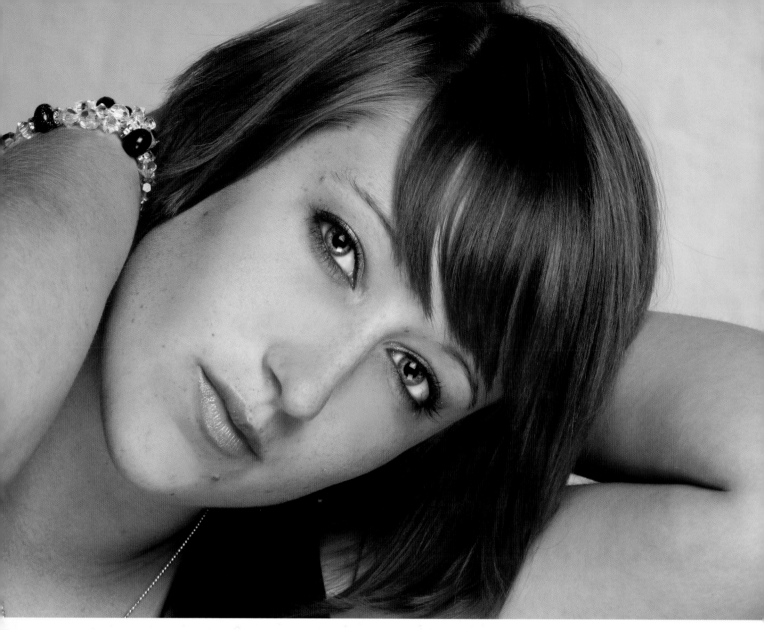

In a glamorous pose, the arms and hands are often used to frame the face and create interesting lines in the composition.

ages have on our clients. A few years back, Kate Hudson had a movie out called *Raising Helen*. In all the ads and displays, she was laying on her stomach with her feet up, legs crossed at the ankles, and a pair of Ugg® boots on. Suddenly, that was the most requested pose—and many girls brought in the shoes and a similar outfit to capture that same look.

As you can imagine, when clients see a striking image like this, then go to the local portrait studio and get a portrait that looks the same as portraits have always looked, they're going to be disappointed—and they're not going to buy. This is why I remind photographers: to succeed, you must fulfill your clients' needs and desires. You must understand human nature and sympathize with the human condition. I don't care if the woman weighs two hundred pounds and wants you take "sexy pictures"—if you accept her money for a sitting, you had better be able to step up to the plate and give her what she wants.

While ideas for resting poses can come to you by watching people while they are resting, glamorous poses come to you by subscribing to the magazines that

your clients subscribe to—*Cosmo, Elle,* etc. Look at the images in the articles, as well as the images in the advertising. Many of your clients want to look just like that.

In glamorous head and shoulders posing, you are basically framing the face with the hands, arms, and even the body. A simple head and shoulders pose can quickly be given a more glamorous look by raising the shoulder closer to the chin. Because my clients will be giving their images to many different people, it's helpful to be able to make this very easy conversion from a resting pose to a glamorous pose without moving anything but the arms and the head. And here's another good tip: when the head is reclined (onto a pillow, the arms, etc.), it gives the portrait a more alluring look.

When creating a more glamorous pose, the arms, hands, and parts of the body not only frame the face, they also create interesting lines within the frame and help determine how to crop the image. As noted previously, in head and shoulders portraits, the head needs a base and the image should be cropped so that the bottom edge of the frame is at the largest point of the base (see page 66 for more on this). This can be where arms are the most flaired away from the body or where the shoulders fill out the frame—but showing too much in glamorous posing, going beyond the widest part of the base, is just as distracting as having no base at all. In the extreme close-ups, the base becomes even more important; without a base, you create a "floating head" look.

When the head is reclined, it gives the portrait a more alluring look.

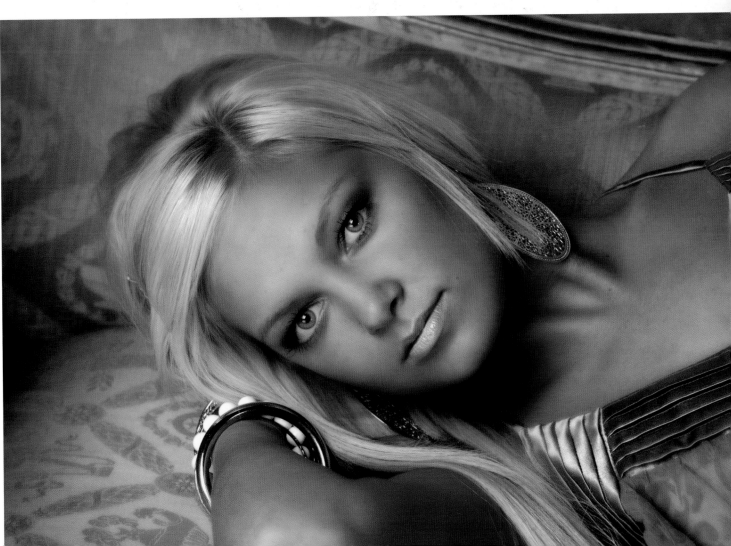

I should note that I have been asked by some photographers why there is a hint of glamour even in my traditional poses. To me, this is part of appearing attractive in a portrait. I am a man in mid-life, not as young or as fit as I used to be, and I take great pride in being a good husband and father. However, when I take a portrait of myself for business, book covers, or articles, I try to make myself look as appealing as possible—at least as appealing as a middle-aged father and husband can look! While I don't fool myself into thinking that twenty-year-old women are going to look at my photograph and think "Oh, baby!", it is nice to make my wife look twice when she first sees the portraits. If we were honest, this is what all of us want to look like in our portraits. Call it glamorous or alluring, this look or feeling adds life to a portrait. I consider it an important part of every image I create.

Show More of the Background

One posing technique we have found helpful, especially in this age of larger clients, is showing more of the background. We encourage clients to bring in personal items to reflect a little more of themselves in their portraits. Yet, while many clients do want to include personal items, a growing number of clients don't want to show enough of themselves to include larger personal items. This

By putting some distance between the subject and the background, large background objects can be included in what is, basically, a head and shoulders portrait.

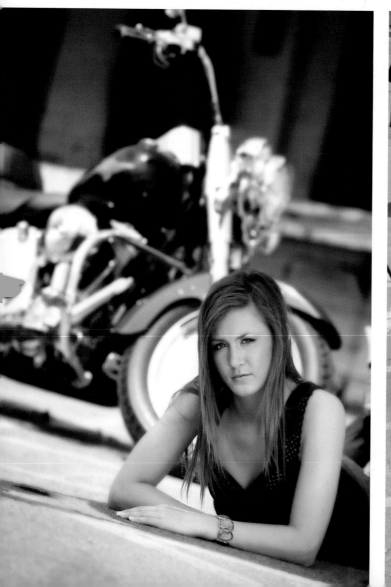

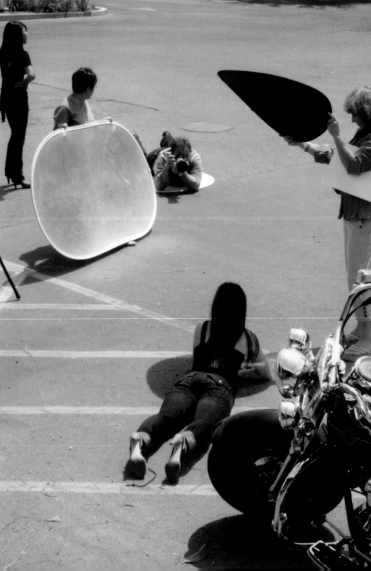

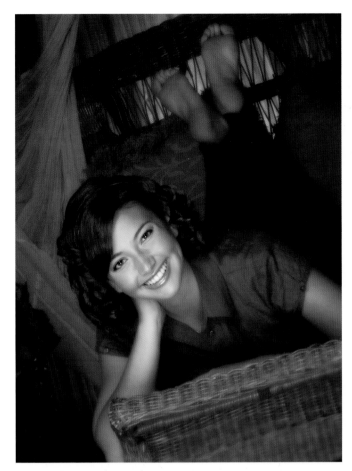

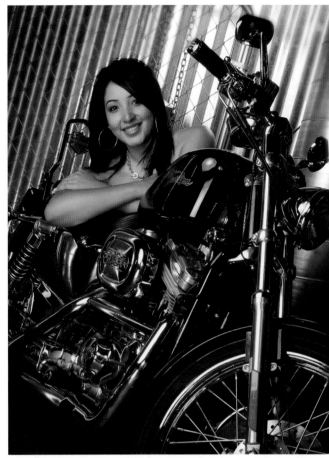

LEFT—*The subject's own body can even be the background in a laying-down pose like this. To show more or less of the body, adjust the angle of the camera to the body.*

RIGHT—*Large props can be placed in front of subjects—a good strategy for subjects who want to use a particular prop but don't want full-length images.*

was also a problem with being able to use two of our popular props (the Harley motorcycle and Dodge Viper) in the studio. Clients who were worried about body size only wanted a head and shoulders portrait.

This idea is really not new—it's just not one that many photographers think of when working with paying clients. To include less of your subject and more of the background, simply pose the subject in front of the car, motorcycle, or other larger item and use that item as the entire background for a head and shoulders pose. The larger the item, the more distance you need between the subject and the item in the background.

This same principle is used when a young lady *does* want to show her body, legs, or shoes, but also wants the facial size of a head and shoulders pose. We simply have the subject face the camera with her body, legs and feet receding further and further into the background. To show more of the body, you simply turn it to an angle, so the head and shoulders aren't hiding it.

Variations

Variations is an exercise I make every photographer in my studio use (including myself) in every session they do. It provides practice in posing because it maximizes each of the poses you know. It also gives your client the maximum variety from each pose they do.

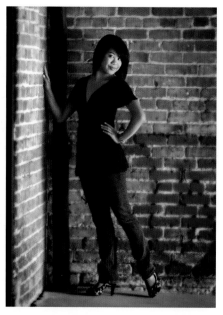

Variations are simple, effective changes you can make in a single pose to give it a completely different look. By changing small elements, like moving just the hands, countless variations become possible. This takes one posing idea you know and turns it into five or ten different poses. With each pose, the photographer is to demonstrate the client's selected pose, determined before the shoot, as well as show the client at least three other variations on the pose.

Male photographers hate this. I have heard it all—"How am I supposed to pose like a girl?" or "I feel really dumb!"—but I don't care how they feel. Until you can pose yourself, feel the way the pose is supposed to look, and demonstrate it to a client, you will never excel at posing. Yes, you get some pretty strange looks when you're not a petite man and you're showing a young girl a full-length pose for her prom dress, but that is the best learning situation I, or any other photographer, can be in.

Using variations also keeps each of your poses in your mind, so no matter how much stress you feel, the poses are there. It's just like multiplication tables—once they stick in your mind, you'll never forget them. This is an important factor, since I have many shooting areas in our main studio and often need to go as quickly as I can from one shooting area to another, working with up to four clients at a time. As you can imagine, this requires some real speed at posing demonstration; I assist each client into the desired pose and then refine it. Then I am off to the next client.

Demonstrating posing variations will also help your client to relax in the pose. Just think of yourself doing any new task. You feel kind of nervous—especially if you have the extra pressure of wanting to look your best and do this task at the same time. Wouldn't you appreciate a person to guide you through the task and demonstrate how to do it as opposed to telling you to "go stand over there and do this"? We always need to put ourselves in our clients' shoes.

No matter how much stress you feel, the poses are there.

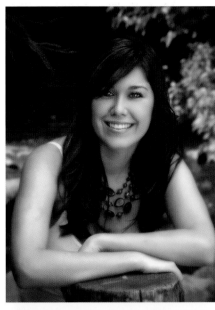

No matter how silly you might feel demonstrating variations, it is the most important part of the learning process. You can look at all the poses shown in this book, get clippings from magazines, and go to seminars, but until you practice them daily in the same situation as you will actually use them, designing flattering poses will always be a challenge to you.

Be Observant

The key to good posing is being observant. Many photographers are in too much of a hurry to start snapping off pictures. I tell my young photographers to take one shot and wait for that image to completely download and be visible on the screen. At that point, I want them to study the image for at least ten seconds. By forcing them to take the time to notice problems in posing, lighting, and expression, the number of obvious problems have gone down considerably.

Many photographers find that they don't have an eye for detail. They constantly find problems (problems they should have picked up on before the portrait was taken) coming out in the final proofs when they show them to the client. If this is your shortcoming,

ABOVE AND FACING PAGE—*Attention to detail is one of the factors that ensures good posing.*

hire someone with a good eye for detail to assist you in your sessions. Their eyes and focus on detail will save you the cost of their salary in lost or reduced orders.

We have a photographer who has been with us for some time. He, like most mature men, has no idea what makes one hair style look good and one look messy. So, I pair him up with one of our younger posers/set movers, who acts like she is a member of the fashion police. She can spot a stray hair or a bad outfit from across the studio. Between the two of them, we have excellent portraits for clients.

7. Working On Location

You'll encounter two major differences when creating a head and shoulders portrait outdoors or on location (rather than in the studio). The first is that you'll need to know how to deal with outdoor or natural lighting. The second concern is placing the subject in such a way that at least a portion of the environment around the subject shows with some detail. After all, it doesn't make since to leave the studio and go to the park if the background for the portraits will be a wash of green texture that could have been duplicated in the studio.

Coordinating the Location and the Clothing

Many of the processes that you must go through in the studio must be done on location, as well. This coordination of every element that will appear in the portrait is what ensures that it will visually make sense.

For example, park scenes are typically darker in tone and more relaxed in their overall feel. As a result, this wouldn't be my first choice for a formal portrait of a bride in a white wedding dress or young lady in an elegant gown. Other locations such as, some architectural locations, can provide an elegant surrounding for more formal clothing (and also higher-key areas that are more suited for a white bridal dress). While you can control your outdoor lighting and let backgrounds step-up to lighter tones, backgrounds typically look best and most natural when they record in the image as they looked to your eye.

We suggest our clients bring medium to darker clothing for park-type locations and medium to lighter clothing for most architectural settings, since most of the time they are lighter in tone. Casual clothing is suggested for standard park locations—and this should reflect the time of year (shorts and dresses for summer; sweaters and jackets for fall). We suggest nicer clothing for most architectural locations—unless it will be a street-scene location, in which case more trendy or harder-looking clothing will be suggested.

Park scenes are typically darker in tone and more relaxed in their overall feel.

White columns form an elegant and well-coordinated background for this outdoor bridal portrait.

The trees, branches, pathways, columns, and roof lines all produce a feeling in the portrait

Just like in the studio, the lines and textures you use in your background locations need to enhance the overall feeling you are trying to create in the portrait. The trees, branches, pathways, columns, and roof lines all produce a feeling in the portrait you are creating. You must select the scene that reflects the feeling you are trying to create, not just head back to your favorite tree because that is where you always go.

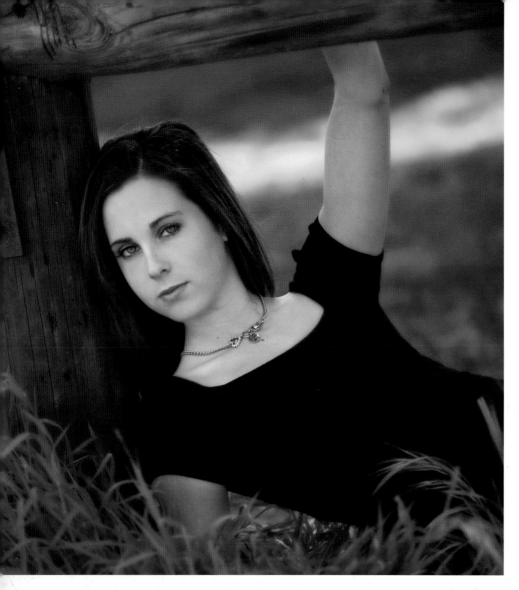

LEFT AND FACING PAGE—*Outdoor images should show the location—the reason you bothered to do the session outdoors!*

Including the Background

The way you pose a person on location can add a great deal of interest to the head and shoulders portrait. On location, more than anywhere else, we use the technique of compressing the body to achieve a head and shoulders head size by bringing the upper body close to the camera and then having the lower body recede into the background. While some might say this is not strictly a head and shoulders pose, this type of portrait will satisfy older purchasers who want a larger facial size and younger purchasers who want to see more of themselves (and their outfits).

Including more of the background, or a certain part of a background that a clients feels is important to include, in a head and shoulders portrait requires some distance; you have to put the background element in the proper perspective to get the correct size. If a client wants to show a building in their head and shoulders pose, most photographers would meet the client at the building and then use small sections of the building in the background. To get the background that the client wants (the whole building) in a head and shoulders pose, you would probably have to meet the client and use an area across or down the

The way you pose a person on location can add a great deal of interest to the portrait.

street to reduce the recorded size of the building (or other object) so that it will fit into the small space of the background area.

The same is true in classic outdoor poses. Many photographers are used to selecting a background for a full length pose, posing the client, then zooming in to take a head and shoulders pose. This often produces a background that is a wash of green—a background that could have been produced in the studio with a green mottled background. The background foliage needs to be closer to the subject in a head and shoulders pose than in a full length to provide some detail.

Although many photographers adjust the height of the camera based on their comfort, there is a huge difference in someone's appearance as you raise and lower the camera angle. On location, there are also big changes in the background. Elevating the camera really high above the subject can achieve a very unique look, as can lowering the camera toward the ground to shoot at an upward angle.

> The background foliage needs to be closer to the subject in a head and shoulders pose.

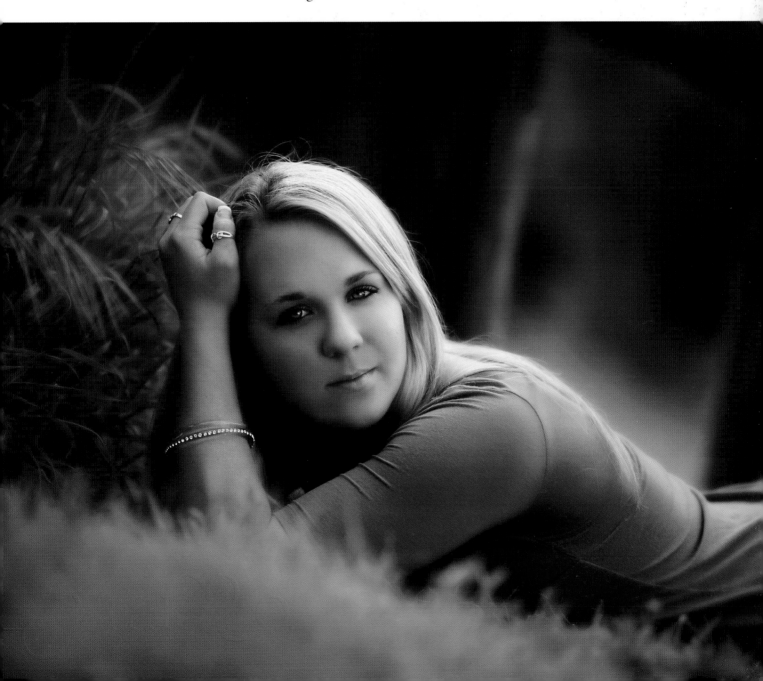

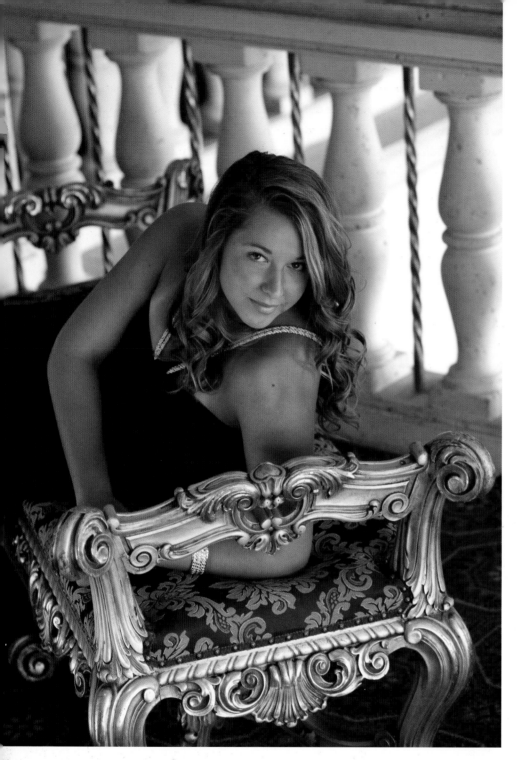

ABOVE AND FACING PAGE—*In each pose, in each situation you have to determine the best angle to take the shot and the best elevation to have the camera. In this situation the choices were many. With the beautiful window light filling the room, we were able to shoot from just about anywhere. By elevating the camera, I could show the beautiful banisters just behind the subject (left); by lowering it, I could show the beautiful columns and ceiling above her (facing page, left). Tilting the camera added another possible variation (facing page, right).*

To further enhance the look of a head and shoulders pose, look for foreground elements to add more depth to the image. The foreground can be something as simple as the trunk of a tree or branches that extend out in front of the subject. Even columns or posts can be used in this way by moving the camera closer to the row of columns and skimming along them.

Lighting
Skip the On-Camera Flash. I guess that I haven't written enough books on outdoor photography, because every time I go to a park, I see professional pho-

tographers (or so they would say!) using an on-camera flash. Let me say it again—even louder: *on-camera flash is not a professional light source for a portrait*. Think about it. Would you use an on-camera flash in the studio? Of course not. So why would you use it outdoors? For professional-quality images, you have two choices: use studio flash or use reflectors. My current choice is to use reflectors, but either source will work.

Studio Flash. If you decide to use flash, choose a studio flash unit with a battery supply or a very long extension cord. You'll also need a modifier to soften the light. I often use umbrellas, but a soft box will work as well. Position the light in the main-light position as we have already discussed.

When metering, read the ambient light first, then set your light to give you the lighting ratio you want. If the background has the same amount of light on it as your main-light source, you are lucky. Most of the time, though, the light will not be the same. As a result, if you want the background to appear as it does to your eye, you will have to adjust your lighting to match the quantity of light hitting the background.

Fortunately, since the light from the flash is only controlled by the f-stop (and the maximum shutter speed at which your camera will sync with flash) and

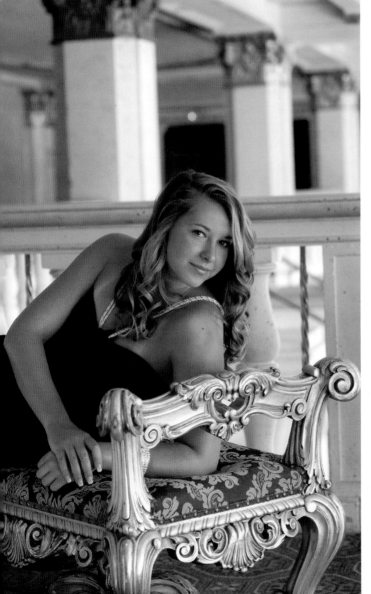

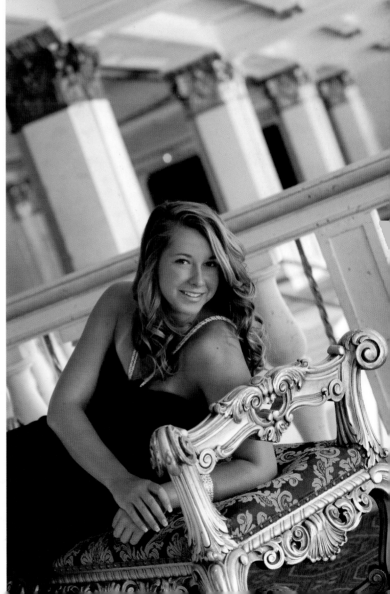

ambient light is controlled by *both* shutter speed and f-stop, you have a great deal of control; you can darken or lighten the background by raising or lowering the shutter speed. Using this technique, you can let the background step up to a high-key look, or you may want to darken a background that is burned up by direct sunlight.

Reflectors. There are two problems with flash: you can't see the exact effect of your lighting on the subject, and you have to haul all that equipment. A better choice for "simplified" outdoor lighting is the use of a reflector. In all my books, 90 percent of the outdoor images are taken with the use of one reflector. There are times and locations when complex arrangements of reflectors, gobos, and even mirrors are needed to produce the portrait I want, but the vast majority of the images are created using one reflector (silver on one side, white on the other).

Often, one reflector is all you need to create a nice outdoor portrait.

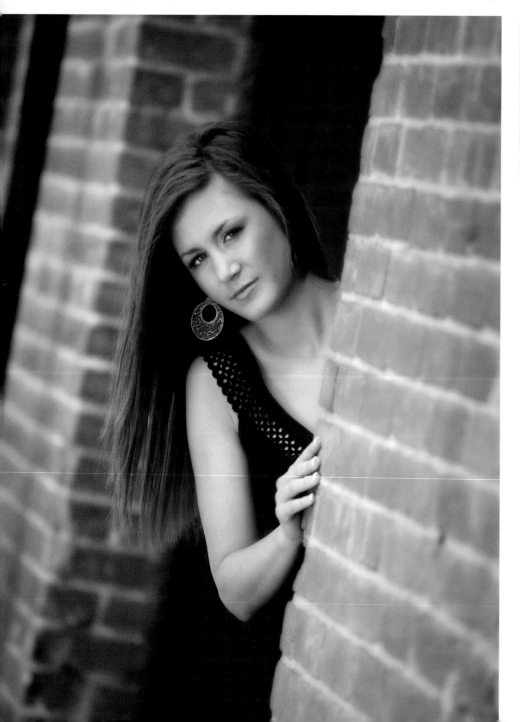

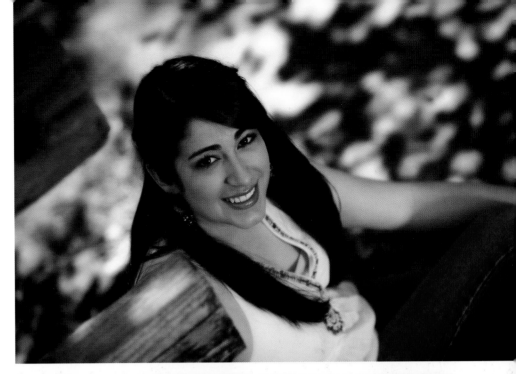

Place the reflector in the main-light position and reflect the sunlight back toward the client.

When working with a reflector, you should always work with the sun to the subject's back. This illuminates the foliage from behind to bring out more color (rather than having the sunlight directly hitting the background areas from the side and burning up the background or creating "hot spots"). If direct sunlight does strike the client, it acts as a hair light rather than streaming down on any area of the face.

Next, place the reflector in the main-light position and reflect the sunlight back toward the client—and notice I said *toward* not *at*. We don't want to blind anyone, here. If there is not a strong backlight and the foliage or background isn't in direct sunlight, I have my assistant use the white side of the reflector and place it close to the subject. If there is a strong backlight, my assistant will use the silver side of the reflector and feather, inching it closer to the subject until I see the lighting effect (and the quantity of light) I want.

Look at the Subject's Eyes. Outdoor lighting can be very complex, which is why many photographers resort to on-camera flash or return to their favorite tree over and over again. But here's the one secret you need to know—the secret to simple light: look at the subject's eyes. It's that simple! When you have the subject as described above (with the sun to the subject's back and the reflector in the main-light position), have your assistant add more light until you first start to see large catchlights in each eye. When you first start to see distinct, beautiful catchlights in the eyes, this is when the intensity of light is just strong enough to become a main-light source. Add more light than this you will overpower the fill provided by the ambient light in the scene. (*Note:* If you add light from the reflector but don't see two catchlights that "pop" from camera position, the light lacks direction and you have basically added a fill source to a fill source.)

I work outdoors every day—in fact, my last appointment each day is an outdoor session, since a beautiful park is only three minutes away from our new studio. I use this lighting principle at all times of the day, in all seasons of the year, and it always works. It always produces salable outdoor portraits.

My last appointment each day is an outdoor session.

In Short . . .

Outdoor and location sessions can be both the most challenging and the most rewarding sessions you do, but success, again, comes back to what the client wants and not what you want to give her. Portraits on location require more control over the session—not only the technical parts of the photography but the human elements, as well. Your clients must be guided into the correct choices to make the outdoor images work. This is exactly what we are going to discuss in the next chapter, which deals with customer service.

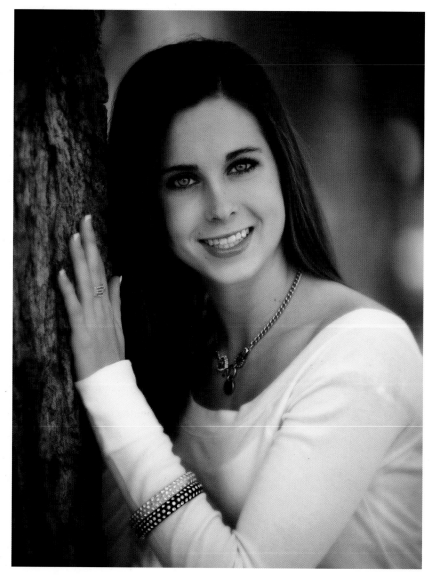

Creating outdoor portraits can be more of a challenge than working in the studio, but the results can also be even more interesting.

8. Customer Service

In this chapter, we are going to briefly discuss the many factors that affect the relationship between you and your clients (or potential clients). What most photographers don't understand is that in *every* business you have a relationship with your clients. Neither person is doing the other a favor, nor can they exist without the other. If you're smart, and intend to stay in business, you'll learn how to make this relationship the best it can be.

Donkeys and Lapdogs

From what I have seen, when photographers struggle and have problems relating to their clients, they fall into two general categories—we'll call them donkeys and lapdogs.

The donkeys make up a good portion of the struggling-photographer demographic. They are mostly disgruntled artists who seem to think they are doing their clients a favor by blessing them with their immense talent. This group feels that they are so talented they should be hugely successful—and are quite peeved because their Honda Civic is a poor excuse for the Mercedes they should be driving. As you can imagine, with all this hostility inside of them, they are not the most warm-and-fuzzy bunch. As a result, they tend to be the source of all the problems they have in their sessions (as well as in their lives), even though they blame the troubles on their terrible clients. While this group does provide clients with direction, it's often with a tone of frustration.

Conversely, you have the lapdogs, a minority group of photographers who are so happy to be in the profession they would do it for free—which is often exactly what happens! The lapdogs count their blessings every time the doorbell rings, because that blessed client who is gracing their studio is putting them one step closer to paying the rent. They are so excited to have a client, and so worried about saying or doing anything that might make them walk away, that they fail to properly educate their clients. "If I tell the client what I charge, they

Learn how to make this relationship the best it can be.

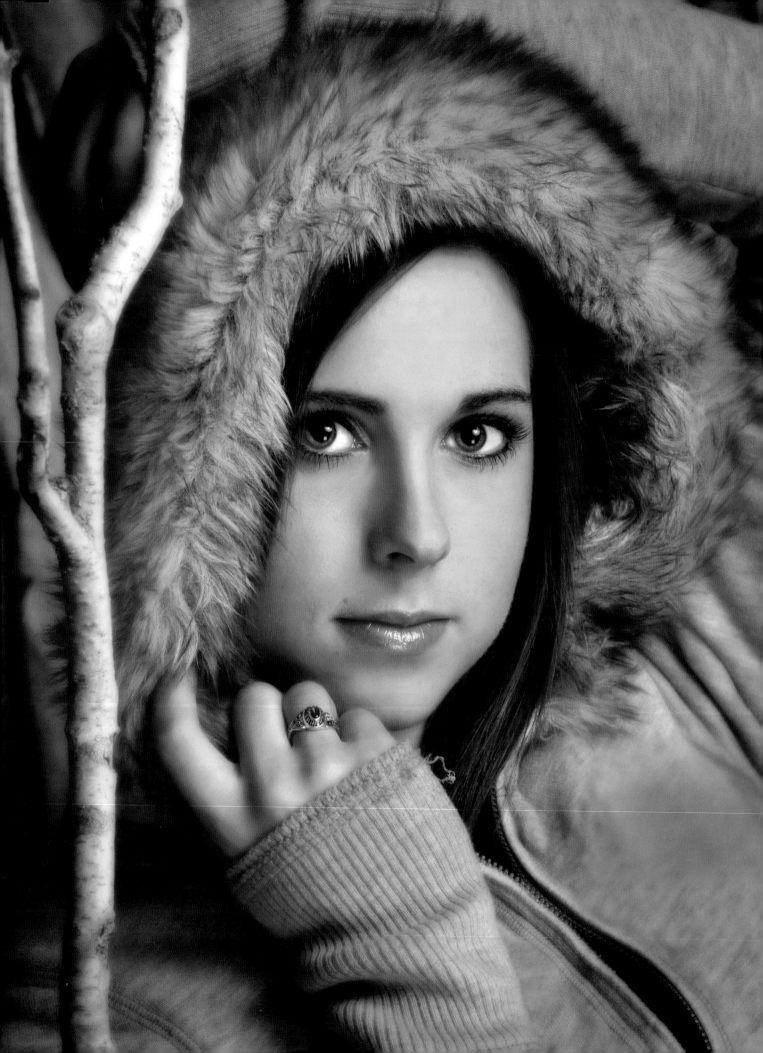

may not have me take their portraits," they think. Or, "If I tell them how to dress and what to plan for their session, they may think I'm too pushy."

While these are both extreme characterizations, photographers with either donkey or lapdog tendencies have one thing in common: they don't understand that to be successful in business you have an equal relationship with your clients—it's almost like a marriage. The donkeys feel superior to the client, and that's not a good way to be if you plan to stay in business. The lapdogs feel inferior to the client and, in today's assertive society, will get eaten alive.

Establish a Mutually Beneficial Relationship

As all counselors will tell you, the best way to keep a relationship healthy is to communicate. You need to tell your clients about your business and you need to ask them what they want. If they have a big stack of money and you can fulfill their needs and desires, you have a client. If they don't have a big enough stack of money, if they have no need for what you provide, or if you can't fulfill their desires, why would you want them to come to your studio? And why should they want to come to your studio? If any of these problems occur, the person is not a client, because they will not order (which is what a client truly is). If they don't want what you offer (or, looking it from the photographer's perspective, if you can't deliver what they want), it's a bad match. Trying to make it work will be a waste of time for both you and the client.

FACING PAGE—*Only when you and the subject are working in harmony can the best possible results be achieved.*

BELOW—*Great customer service starts with making sure what the customer wants is something you can deliver.*

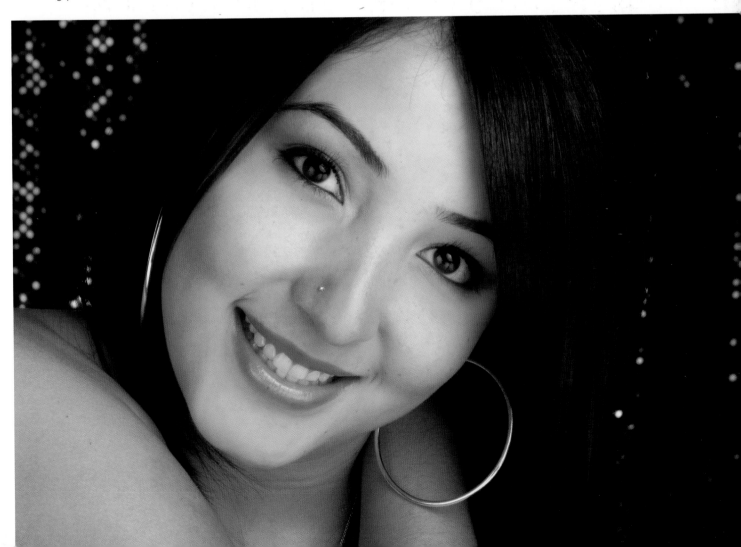

Customer service starts by educating your clients about your business. That's the only way they can make the decision to come to you or to go somewhere else. This is how you qualify them and ensure that you want them as a client. Once you both decide this relationship could work, you need to find out exactly what they want and then you have to explain to them how to get what they want (clothing choices, makeup, type of session, time of year, etc.). Finally, you need to let them know how much what they want is going to cost.

Define Your Market

Photographers are one of the only groups of businesspeople who fear defining their market. No matter how little you charge, there are going to be some people who won't pay your price. No matter how good you are, there are going to be some people who don't like your style. High-end department stores like Macy's and Bloomingdale's aren't for everyone—and neither are discount and closeout stores like Big Lots and Walmart. However, each of these companies has clearly defined their business so that their potential customers know where to go. You don't look for an Armani suit at Walmart, and a single mother of five children doesn't typically go shoe shopping at Bloomingdales.

Clients need to know what you offer so they can decide if it's what they are looking for.

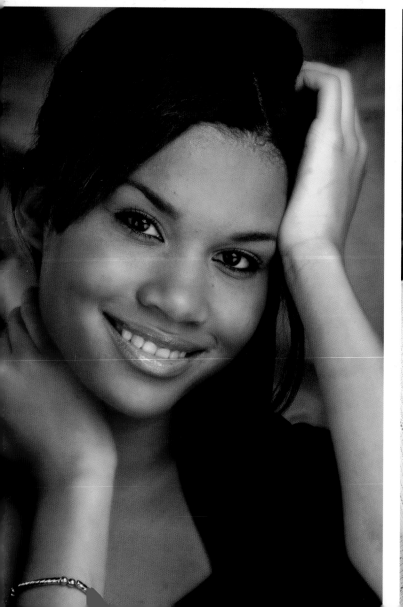

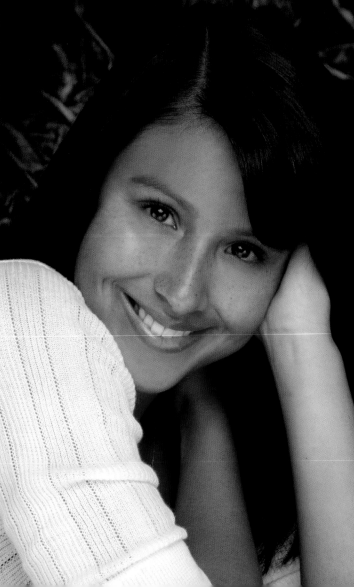

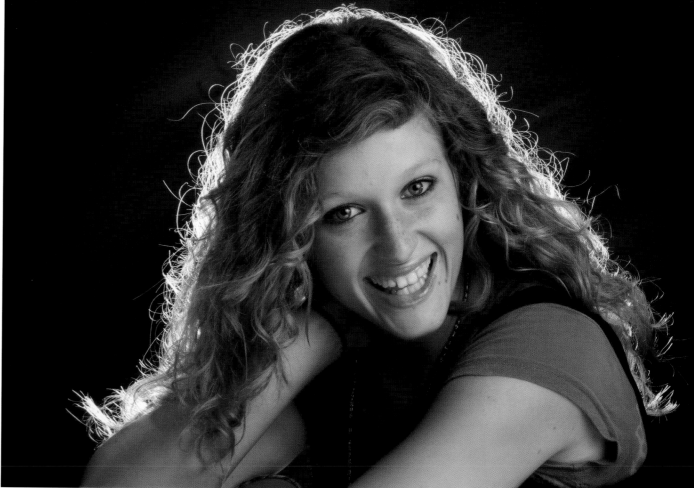

Not every client has to be a good match for your business—you just need to attract the ones that are a good fit.

Your business needs to be as clearly defined to your potential clients as any of these businesses are to you and me. Everything from your web site, to your business card and stationary, to your studio design should reflect the real image of your business. Many photographers have a Bloomingdales look in their marketing materials, but a Walmart feel in their customer service, studio, and pricing. Clients that want a Bloomingdales studio are not going to be happy with your Walmart studio, so you have wasted your time and theirs. The reverse is also true when more upscale studios makes the mistake of presenting a modest look in their marketing, then surprising prospective clients with high prices. In these situations, even if the client does book a session, the chances are very good that they will not order. On some level they will feel as though you have tricked them—and in a relationship, you don't deceive anyone.

Don't Try to Please Everyone

When I hear people in the general public talk about our studio they say, "Wow, they are expensive—but they're good," or "They're expensive—and that's where I'm going for my senior portraits." Of course, I also hear, "They're just too expensive." Many photographers would hear comments like these, freak out, and lower their prices. To me, hearing this lets me know that what I am doing is working.

We *do* charge more than most studios. We have a Dodge Viper, a Harley, and a huge variety of very large, very expensive sets, so of course we are going to charge more than other studios that offer just a few painted backgrounds. While many local studios have assistant photographers taking all (or at least a portion) of each senior's session, I photograph each session myself—and, not to toot my own horn, but my clients are getting to work with an experienced professional who is the author of numerous books, articles, etc. The clients who choose my studio expect to pay for those benefits, and if they suddenly discovered we were the cheapest studio in town, they would feel like something was wrong. Conversely, because everything about my studio reflects our quality and pricing, clients who are looking for a bargain know that we're not a good fit for them and seek other options. That's how it should be. Not every client is a good fit for what we do and there's no point wasting our time, or theirs, trying to fit a square peg in a round hole.

Look at your studio, the work you create, the price you charge, and the basic description of your best clients. Be honest—this doesn't do any good if you let your ego overrule your logic. Once you define your studio and your perfect customer, every single thing that the buying public sees should reflect that image and be appealing to that particular type of client. If you do this, your phone will ring—and the callers will be exactly the type of clients that are looking for a studio like yours.

Take Control of Your Business

The next step is to train your staff to qualify callers to ensure that when you take a session, you will have an order. In our studio, we have an extremely high rate of paid sessions ordering. With all the senior portrait sessions we do, fewer than ten clients failed to order from their paid sessions last school year. These nine families didn't order because they left every part of the scheduling process up to the senior—and when they received all the information we sent to their home, they didn't read it. As a result, the parents had no idea how they were ordering and how much our packages are. This is a problem that is inherent in senior portrait photography, because the decision-maker is often *not* the person who is actually the buyer!

The reason we have so few people who fail to order is because we have planned every step the client must take to go from a potential client to a satisfied client. What does this have to do with head and shoulders photography? Well, until you take control of your business and earn the respect of your clients, you will never be able to control your sessions. Until your potential clients respect you and trust your company, they will never follow the suggestions that ensure the success of their session.

Many photographers spend their entire professional careers never understanding that the *business* aspects of their studios and the *creative* aspects of

Clients who are looking for a bargain know that we're not a good fit.

their studios are not separate. One only works as well as the other. I receive e-mails from photographers who go on about their "art" and tell me I spend too much time in my books talking about the client and money; they just want to know about lighting, posing, and f-stops. This is the type of person who needs to read this the most. Without a sound business system that fosters a relationship between you and your client, you will never have the opportunity to enjoy practicing your art as a business—you'll just have an expensive hobby.

Some young photographers look at established local photographers who are successful and wonder why they are successful when many other photographers in their local area take better portraits. This proves the importance of the business system and the relationship between you and your clients. With the right business system, you can sell a million dollars of mediocre photography (if you don't believe, this look at the national studio chains and school photography businesses). Without it, you can't make a living—even with the best photography product to sell.

No matter how great your images are, without a sound business system, you'll just have an expensive hobby in photography, not a business.

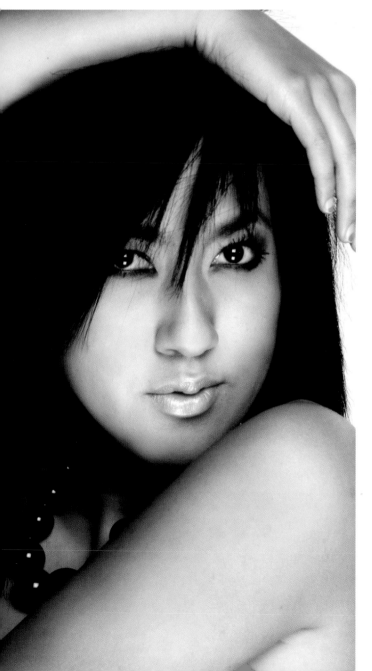

9. Postproduction

I believe that the enhancements done to each ordered portrait are a part of the creation of each of my images. That being said, though, I also feel strongly that you must get the image recorded properly in each file so that only minimal retouching, with little or no significant correction, is needed. At first, that may sound like I'm contradicting myself—but let me explain.

Enhancement is a part of the creation process. It helps give your images a consistent look that lets them be identified as being your style and your work. However, *corrections* should only need to be done when it is impossible to correct problems in the camera room. No matter how good you are at corrective lighting and posing, for example, you can't hide braces or make a face attached to a three-hundred-pound body look thin enough. These issues require corrections. You should not, however, waste time making postproduction corrections for things that can be concealed just by having the client wear the right clothes, or taking a few seconds to refine a pose and tweak the lighting.

Delegate Postproduction

I am going to make a bold statement here: if you retouch and enhance your own images, you're making a serious mistake—at least from a personal and business standpoint. Behind the camera, I can generate a lot of money for my business. At home, I can be a father to my children and a husband to my wife, enjoying times that money can not buy. When I get behind a computer, I have just replaced a $12/hour employee. I'm either sacrificing my business profit or my home life, and that's stupid.

I go to conventions and seminars and hear photographers talking about the four-minute slideshow they personally spent twenty-three hours designing for this program. All I can think is, "Why??" (And as that same speaker continues, don't be surprised if he mentions that he has just said goodbye to wife number three and can't figure out why he can't find a good woman!) What can be ac-

I feel strongly that you must get the image recorded properly in each file.

FACING PAGE—*Simple retouching with the Clone tool is used to optimize each subject's complexion.*

complished on computers is amazing—so hire some talented young people and pay them to create it for you. You have three jobs in your business and in your life: take pictures, train your staff, and spend time with your family and friends.

Standardize Your Procedures

As we all know, there are many ways to accomplish the same job in Photoshop, however each technique for accomplishing a particular job will create a certain look. If you have two different people retouch the same image, giving them no instructions, you will typically end up with images that look like they were photographed by two different photographers. To ensure consistency, you need to define a step-by-step method of enhancement that each and every person working on your images will follow. What strategy you use to enhance your images is a personal decision.

Our Approach to Enhancement

The Skin. As photographers move toward automated types of retouching that use diffusion to soften the skin, I feel like we are seeing more and more "plastic" people. They don't have any texture on their skin, so they look a little *too* perfect. I prefer retouching each ordered image by hand, using the Clone Stamp tool on a low opacity setting to retouch acne, reduce wrinkles and dark areas, and slightly soften the overall texture of the skin. While there are other tools and

Enhancing the eyes is a quick but important procedure that makes a big difference in the look of a portrait.

other methods, this is the look I prefer and how each image from my studio is produced.

The Eyes. Once the skin is retouched, we then enhance the eyes. We use the Dodge tool to define the catchlights and bring out the eye color. The hardest part of the eye-enhancement is making sure the enhancement looks natural in each eye. Many who are new to Photoshop will enhance the eyes to make each identical in color and to match the size of the catchlights. The perfect enhancement, however, is one you don't notice—one that uses the light patterns that already exist in the original image.

Shadowing. The next thing our retouchers look at is the shadowing. If I decided to work with a higher lighting ratio to thin the face using a very dark shadow, the retoucher will look at the shadow side of the nose and other shadow areas to see if they need to be lightened. If needed, they will use the Cloning Stamp tool at a low opacity to soften the shadow slightly and not remove it.

And That's It! This is our basic retouching that is done on each image—and that's it. How can we get by with so little enhancement while other photographers aren't? I work on fixing obvious problems in the studio, not on the computer. I shoot with digital the same way as I used to shoot on film. Just because you *can* make difficult correction and enhancements on the computer doesn't mean you *should*. With film, we were able to do only negative retouching, with any additional correction being done as artwork on each individual print. When you grow up shooting this way, you are very careful about what you create; mistakes that digital photographers now make every day (then waste time fixing in Photoshop) used to cost film photographers a fortune. (Of course, the digital photographers of today pay a price, too—typically their personal lives!)

Our Approach to Correction

Look for Simple Fixes. Because we are a higher-priced studio, our retouchers do also look at each image to see if there are any simple corrections—things that could be done in a matter of seconds—that would greatly enhance the image. For example, because of the amount of traffic in our high-key area, there are always little marks on the floor that can be easily eliminated with a simple brighten and blur action.

For Heavy Subjects. *Liquify.* For very heavy subjects, the retouchers look at the face and body to find obvious bulges or areas that could quickly be thinned down. Two effective ways to handle problems of weight are using the Liquify filter (Filter>Liquify) to flatten bulges. Simply select around the bulge. Then, choose the Forward Warp tool from the upper left-hand corner of the dialog box. Then, adjust the size of the brush as needed and push in the bulge.

Stretching. The second technique is very effective for thinning a person, especially in the face. You simply go to Image>Image Size, turn off all the Constrain Proportions box, and increase the size of the image to stretch the face

> The next thing our retouchers look at is the shadowing.

slightly from top to bottom. (*Note:* This direction will obviously depend on the orientation being vertical or horizontal, as well if a vertical image is rotated to it's proper angle or left on its side as it was captured.) There is no secret number to stretching the image, just make small incremental increases until you start to notice it has been stretched, then step backwards until you don't notice the effect. This only works when all parts of the body that are seen are vertical. If the subject has their arms crossed, the arms would be running horizontally through the frame and stretching the image would make them appear larger.

Vignetting. The final effect we use is to vignette the majority of images, which is nothing more than darkening the edges of low-key photographs and blurring the edges of high-key photographs. Vignettes hold the viewer's atten-

> Vignettes hold the viewer's attention by softening or eliminating lines that lead outside of the frame.

LEFT—*Vignetting is used to give many of our images a finished look.*

FACING PAGE—*Adding artistic effects to your images can be a profitable use of postproduction time.*

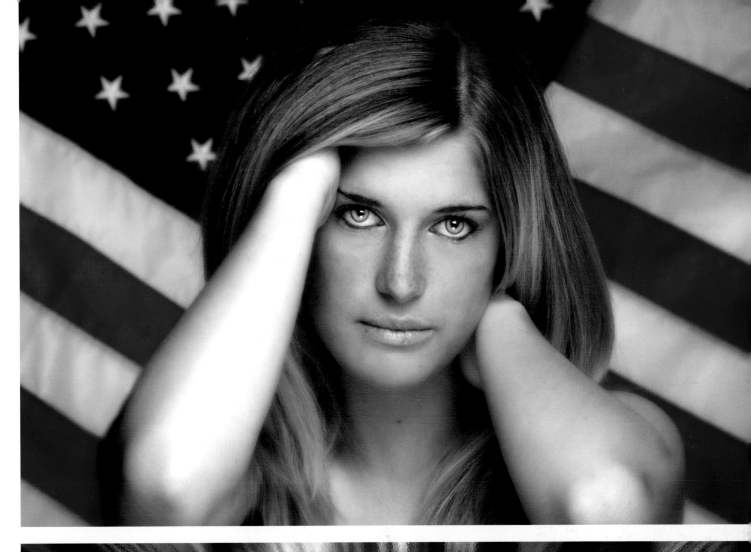
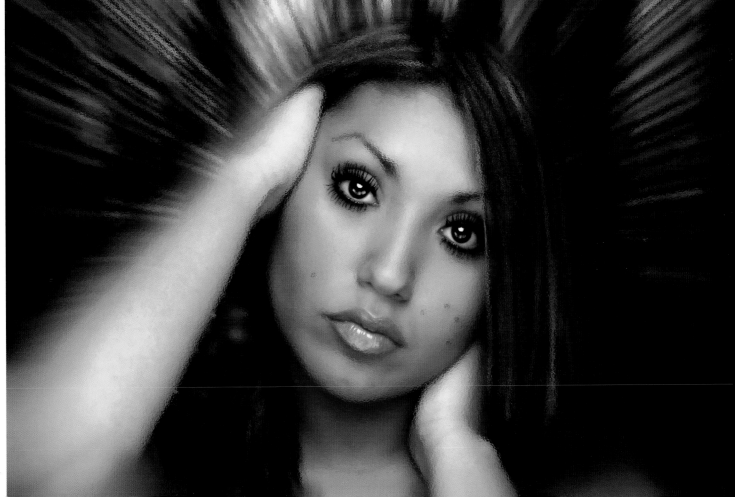

tion by softening or eliminating lines that lead outside of the frame. Vignettes aren't used on every image, but they give a finished look to most of our high- and low-keys portraits.

To add a vignette, we simply make an oval shaped selection over the subject with the Marquee tool, which has its Feather setting at 250 pixels. Then, right mouse click over the selected area and click on Select Inverse. At this point, you can darken the selected area for lower-key images or blur the area for high-key images as you see fit.

Clients Pay for Other Corrections. These simple procedures are all that 99 percent of our images need—but there are times when a client has a specific problem that couldn't be corrected in the camera room. If that is the case, the client pays for the correction. For example, if someone doesn't like the glare on their eyeglasses (they insisted on wearing them even after you explained several times that there would be glare), that client is billed for the correction.

Prevent Copying

The next—and last—two steps in the processing of the order are probably the most important from a profit standpoint. In this digital age, where every home has a decent computer and either a flatbed scanner or a printer with a decent scanner built into it, copying of our work is a serious problem. Today, younger people are accustomed to not paying for copyrighted products (music, for example), but even more upscale older clients who would have never have thought of copying your work ten years ago now see copying as a way to save money. To ensure your business is successful, you must stop your clients from copying your images.

To accomplish this, we do three things—and if you do them, you will save the cost of this book hundreds if not thousands of times over.

Add Your Logo. The first thing you must do is to create a logo that goes on each and every image that leaves your studio. We designed ours to be almost transparent, similar to the watermark on images you see on the web. The idea is to have your studio name on the front of each image, so when a client takes one of your prints to a lab—say at Target or Kinko's—to make more copies, the more reputable business will see the logo and not violate the copyright laws by duplicating it. That being said, you don't want the logo to be *too* prominent or it will look as though you are blatantly advertising across the front of your clients' portraits. It should be very subtle, so you really don't notice it just looking at the portrait.

Be prepared: when you first do this, some clients will complain—but those will typically be clients that have taken your work to Kinko's and been sent away; no client has ever complained about our logo at the time they picked their order up at the studio. When a client does complain about the logo, we explain that practically every product you buy has a logo on it—from clothing

You must stop your clients from copying your images.

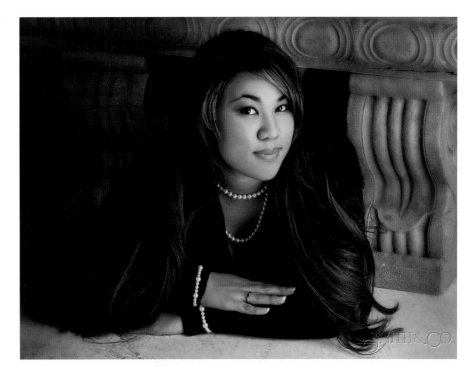

A discrete logo helps prevent illegal copying without intruding on the appeal of the image.

The lines of texture pop out when copying and degrade the quality of the copy.

to cars—and we are no different. Most clients want our logo, just like most women want the Coach label on the outside of their handbag. We finish by saying that, "Typically, the only time someone is bothered by the logo is when they are trying to copy one of our images and are turned away because of the copyright laws." This statement doesn't accuse them, but it uses your experience with other clients to let them know that *you* know the real reason they are calling. After these comments, there is little argument.

Add Texture to the Prints. The second step in stopping clients from copying is to texture your prints. Many photographers today don't even know what texturing is, but years ago, some studios would sell linen or canvas texturing on their final portraits and charge a premium price for it. The idea never really caught on because most clients didn't want to pay more for a textured print. However, the texture on the print makes high-quality copying almost impossible. This type of texture is offered by most labs, or you can buy a texture machine. These work like the older rollers for wringing the water out of clothing. There are two heavy rollers with the texture pattern on them, and as the print goes through the two rollers the pressure embeds a permanent texture on the print surface.

The most popular texture is linen. A canvas texture is too smooth to stop copying, and a pebble texture is too heavy; it becomes an eyesore in your portraits. You don't notice a linen texture at a normal viewing distance or under glass, but the lines of texture pop right out when copying and degrade the quality of the copy. As a result, copies from these textured prints will not be something that most paying clients will want to give away. If your lab doesn't offer roller textures (some machines use a screen), see page 123 and e-mail me for the

name of a company that sells the machines. While they can run $1500 or more, it is an investment in your profits.

When using texture and logos on your work, you must make sure that every print your clients see in your studio has the same texture and logo on it—you do not want it to be a surprise when they pick up their order. In our studio, we only texture prints up to 8x10 inches, but our logos are on every print size.

Stop Selling Single Portraits. The last step in eliminating copying is to stop selling single portraits from a session. Do you have clients that order one 8x10 and nothing else from a beautiful session? Then you have just identified your worst copiers—copiers who don't even care if you know they are copying or not. These are the people who think that they are entitled to copy your work because they paid a sitting fee. The average person will at least order a small package or a few prints so you don't suspect them of copying. The single portrait buyer is the worst, so stop selling them.

Notice I said stop *selling* them, not stop *offering* them. If a client wants a single image, sell it to her—just make sure it is so expensive that it is same price as a small package would be. Some photographers eliminate this problem with a minimum print order. Everyone knows that the cost of a portrait is in the retouching, enhancement, and testing to make sure that final image is flawless. After that, whether you print one portrait or ten, the cost is about the same—at least that is the way you explain it to your clients when they ask why one portrait is the same price as your smallest package.

To sell individual, untextured prints with no logo on them is giving your work away. It also causes suspicion in your relationship with your client; you can't look at your clients as copyright violators and still treat them with the respect they deserve. In reality, people most often do the right thing. If you remove the temptation to do the wrong thing, you'll be secure in the knowledge that your clients are treating you with the same respect you show them.

To sell individual, untextured prints with no logo on them is giving your work away.

In Closing

I hope that you have enjoyed this book. If you have any questions or comments you can e-mail me at: jeff@jeffsmithphoto.com. I try to return e-mails within 48 hours. For additional products you can visit our web site at www.smithandcostudios.com or www.amherstmedia.com.

Index

OUTDOOR AND LOCATION PORTRAIT PHOTOGRAPHY, 2nd Ed.

Jeff Smith

Learn to work with natural light, select locations, and make clients look their best. Packed with step-by-step discussions and illustrations to help you shoot like a pro! $34.95 list, 8.5x11, 128p, 80 color photos, index, order no. 1632.

JEFF SMITH'S POSING TECHNIQUES FOR LOCATION PORTRAIT PHOTOGRAPHY

Use architectural and natural elements to support the pose, maximize the flow of the session, and create refined, artful poses for individual subjects and groups—indoors or out. $34.95 list, 8.5x11, 128p, 150 color photos, index, order no. 1851.

CORRECTIVE LIGHTING, POSING & RETOUCHING FOR DIGITAL PORTRAIT PHOTOGRAPHERS, 2nd Ed.

Jeff Smith

Learn to make every client look his or her best by using lighting and posing to conceal real or imagined flaws—from baldness, to acne, to figure flaws. $34.95 list, 8.5x11, 120p, 150 color photos, order no. 1711.

PROFESSIONAL DIGITAL PORTRAIT PHOTOGRAPHY

Jeff Smith

Because the learning curve is so steep, making the transition to digital can be frustrating. Author Jeff Smith shows readers how to shoot, edit, and retouch their images—while avoiding common pitfalls. $29.95 list, 8.5x11, 128p, 100 color photos, order no. 1750.

PROFITABLE PORTRAITS
THE PHOTOGRAPHER'S GUIDE TO CREATING PORTRAITS THAT SELL

Jeff Smith

Learn how to design images that are precisely tailored to your clients' tastes—portraits that will practically sell themselves! $29.95 list, 8.5x11, 128p, 100 color photos, index, order no. 1797.

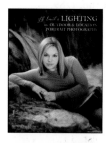

JEFF SMITH'S LIGHTING FOR OUTDOOR AND LOCATION PORTRAIT PHOTOGRAPHY

Learn how to use light throughout the day—indoors and out—and make location portraits a highly profitable venture for your studio. $34.95 list, 8.5x11, 128p, 170 color images, index, order no. 1841.

SUCCESS IN PORTRAIT PHOTOGRAPHY

Jeff Smith

Many photographers realize too late that camera skills alone do not ensure success. This book will teach photographers how to run savvy marketing campaigns, attract clients, and provide top-notch customer service. $29.95 list, 8.5x11, 128p, 100 color photos, order no. 1748.

THE BEST OF TEEN AND SENIOR PORTRAIT PHOTOGRAPHY

Bill Hurter

Learn how top professionals create stunning images that capture the personality of their teen and senior subjects. $34.95 list, 8.5x11, 128p, 150 color photos, index, order no. 1766.

PORTRAIT PHOTOGRAPHER'S HANDBOOK, 3rd Ed.

Bill Hurter

A step-by-step guide that easily leads the reader through all phases of portrait photography. This book will be an asset to experienced photographers and beginners alike. $34.95 list, 8.5x11, 128p, 175 color photos, order no. 1844.

MASTER POSING GUIDE FOR PORTRAIT PHOTOGRAPHERS

J. D. Wacker

Learn the techniques you need to pose single portrait subjects, couples, and groups for studio or location portraits. Includes techniques for photographing weddings, teams, children, special events, and much more. $34.95 list, 8.5x11, 128p, 80 photos, order no. 1722.

PROFESSIONAL MODEL PORTFOLIOS
A STEP-BY-STEP GUIDE FOR PHOTOGRAPHERS

Billy Pegram

Learn to create portfolios that will get your clients noticed—and hired! $34.95 list, 8.5x11, 128p, 100 color images, index, order no. 1789.

THE PORTRAIT PHOTOGRAPHER'S GUIDE TO POSING

Bill Hurter

Posing can make or break an image. Now you can get the posing tips and techniques that have propelled the finest portrait photographers in the industry to the top. $34.95 list, 8.5x11, 128p, 200 color photos, index, order no. 1779.

MASTER LIGHTING GUIDE
FOR PORTRAIT PHOTOGRAPHERS

Christopher Grey

Efficiently light executive and model portraits, high and low key images, and more. Master traditional lighting styles and use creative modifications that will maximize your results. $29.95 list, 8.5x11, 128p, 300 color photos, index, order no. 1778.

DIGITAL PORTRAIT PHOTOGRAPHY OF TEENS AND SENIORS

Patrick Rice

Learn the techniques top professionals use to shoot and sell portraits of teens and high-school seniors! Includes tips for every phase of the digital process. $34.95 list, 8.5x11, 128p, 200 color photos, index, order no. 1803.

MARKETING & SELLING TECHNIQUES
FOR DIGITAL PORTRAIT PHOTOGRAPHY

Kathleen Hawkins

Great portraits aren't enough to ensure the success of your business! Learn how to attract clients and boost your sales. $34.95 list, 8.5x11, 128p, 150 color photos, index, order no. 1804.

HOW TO CREATE A HIGH PROFIT PHOTOGRAPHY BUSINESS
IN ANY MARKET

James Williams

Whether your studio is in a rural or urban area, you'll learn to identify your ideal client, create the images they want, and watch your financial and artistic dreams spring to life! $34.95 list, 8.5x11, 128p, 200 color photos, index, order no. 1819.

MASTER POSING GUIDE
FOR CHILDREN'S PORTRAIT PHOTOGRAPHY

Norman Phillips

Create perfect portraits of infants, tots, kids, and teens. Includes techniques for standing, sitting, and floor poses for boys and girls, individuals, and groups. $34.95 list, 8.5x11, 128p, 305 color images, order no. 1826.

WEDDING PHOTOGRAPHER'S HANDBOOK

Bill Hurter

Learn to produce images with technical proficiency and superb, unbridled artistry. Includes images and insights from top industry pros. $34.95 list, 8.5x11, 128p, 180 color photos, 10 screen shots, index, order no. 1827.

RANGEFINDER'S PROFESSIONAL PHOTOGRAPHY

edited by Bill Hurter

Editor Bill Hurter shares over one hundred "recipes" from *Rangefinder's* popular cookbook series, showing you how to shoot, pose, light, and edit fabulous images. $34.95 list, 8.5x11, 128p, 150 color photos, index, order no. 1828.

SOFTBOX LIGHTING TECHNIQUES
FOR PROFESSIONAL PHOTOGRAPHERS

Stephen A. Dantzig

Learn to use one of photography's most popular lighting devices to produce soft and flawless effects for portraits, product shots, and more. $34.95 list, 8.5x11, 128p, 260 color images, index, order no. 1839.

PROFESSIONAL PORTRAIT POSING
TECHNIQUES AND IMAGES FROM MASTER PHOTOGRAPHERS

Michelle Perkins

Learn how master photographers pose subjects to create unforgettable images. $34.95 list, 8.5x11, 128p, 175 color images, index, order no. 2002.

STUDIO PORTRAIT PHOTOGRAPHY OF CHILDREN AND BABIES, 3rd Ed.

Marilyn Sholin

Work with the youngest portrait clients to create cherished images. Includes techniques for working with kids at every developmental stage, from infant to preschooler. $34.95 list, 8.5x11, 128p, 140 color photos, order no. 1845.

MONTE ZUCKER'S PORTRAIT PHOTOGRAPHY HANDBOOK

Acclaimed portrait photographer Monte Zucker takes you behind the scenes and shows you how to create a "Monte Portrait." Covers techniques for both studio and location shoots. $34.95 list, 8.5x11, 128p, 200 color photos, index, order no. 1846.

PROFESSIONAL PORTRAIT PHOTOGRAPHY
TECHNIQUES AND IMAGES FROM MASTER PHOTOGRAPHERS

Lou Jacobs Jr.

Veteran author and photographer Lou Jacobs Jr. interviews ten top portrait pros, sharing their secrets for success. $34.95 list, 8.5x11, 128p, 150 color photos, index, order no. 2003.

EXISTING LIGHT
TECHNIQUES FOR WEDDING AND PORTRAIT PHOTOGRAPHY

Bill Hurter

Learn to work with window light, make the most of outdoor light, and use fluorescent and incandescent light to best effect. $34.95 list, 8.5x11, 128p, 150 color photos, index, order no. 1858.

50 LIGHTING SETUP FOR PORTRAIT PHOTOGRAPHERS

Steven H. Begleiter

Filled with unique portraits and lighting diagrams, plus the "recipe" for creating each one, this book is an indispensible resource you'll rely on for a wide range of portrait situations and subjects. $34.95 list, 8.5x11, 128p, 150 color images and diagrams, index, order no. 1872.

THE SANDY PUC' GUIDE TO CHILDREN'S PORTRAIT PHOTOGRAPHY

Learn how Puc' handles every client interaction and session for priceless portraits, the ultimate client experience, and maximum profits. $34.95 list, 8.5x11, 128p, 180 color images, index, order no. 1859.

MINIMALIST LIGHTING
PROFESSIONAL TECHNIQUES FOR LOCATION PHOTOGRAPHY

Kirk Tuck

Use small, computerized, battery-operated flash units and lightweight accessories to get the top-quality results you want on location! $34.95 list, 8.5x11, 128p, 175 color images and diagrams, index, order no. 1860.

SIMPLE LIGHTING TECHNIQUES
FOR PORTRAIT PHOTOGRAPHERS

Bill Hurter

Make complicated lighting setups a thing of the past. In this book, you'll learn how to streamline your lighting for more efficient shoots and more natural-looking portraits. $34.95 list, 8.5x11, 128p, 175 color images, index, order no. 1864.

SCULPTING WITH LIGHT

Allison Earnest

Learn how to design the lighting effect that will best flatter your subject. Studio and location lighting setups are covered in detail with an assortment of helpful variations provided for each shot. $34.95 list, 8.5x11, 128p, 175 color images, diagrams, index, order no. 1867.

500 POSES FOR PHOTOGRAPHING WOMEN

Michelle Perkins

A vast assortment of inspiring images, from head-and-shoulders to full-length portrsits, and classic to contemporary styles—perfect for when you need a little shot of inspiration to create a new pose. $34.95 list, 8.5x11, 128p, 500 color images, index, order no. 1879.